COLLINS

PASTEL painter's

Question and Answer Book

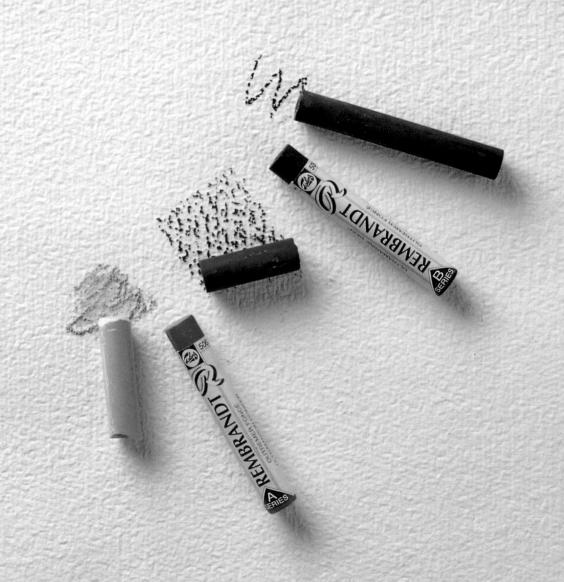

PASTEL painter's

Question and Answer Book

50 pastel painting problems and how to solve them

DAVID CUTHBERT

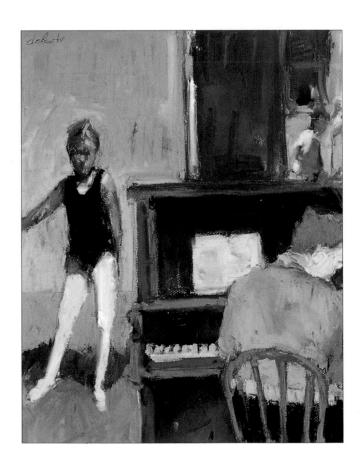

First published in 1996 by HarperCollins Publishers London

Copyright © 1996 Quarto Publishing plc

All rights reserved. No part of this publication may be reproduced or stored in a retrieval system or transmitted in any form or by any means, electronic or mechanical including photocopying, recording or information storage and retrieval system now known or to be invented without prior permission in writing from the publisher.

A catalogue record for this book is available from the British Library

ISBN 0 00 412793 5

This book was designed and produced by Quarto Publishing plc The Old Brewery 6 Blundell Street London N7 9BH

Designer Anne Fisher
Senior Art Editors Liz Brown, Penny Cobb
Senior Editors Maria Morgan, Kate Kirby
Editor Hazel Harrison
Photographers Colin Bowling, Paul Forrester
Picture Researcher Jo Carlill
Picture Manager Giulia Hetherington
Publishing Director Mark Dartford
Art Director Moira Clinch

Typeset in Great Britain by Central Southern Typesetters, Eastbourne Manufactured in Singapore by Eray Scan Pte Ltd Printed in China

Title recto: The Accompanist by Jody dePew McLeane

6 Foreword

8 MAKING A START

- 10 Pastel types
- 14 A basic palette
- 18 Paper colour
- 22 Paper texture
- 26 Choosing paper size
- 28 Looking after your work

30 COLOUR

- 32 Colour mixing
- 36 Identifying colours
- 38 Light colours
- 40 Avoiding muddy colour
- 44 Colour and tone
- 48 Colour unity
- 50 Landscape greens
- 54 Skin tones
- 58 Extending your palette
- 62 Shadow colours
- 64 Creating highlights

CONTENTS

66 COMPOSING THE PICTURE

- 68 On the spot landscape
- 70 Choosing a viewpoint
- 72 Surfaces and edges
- 74 Editing out detail
- 76 Placing the subject
- 80 Abstracting from nature
- 84 Dynamic composition
- 86 Capturing movement
- 88 Controlling a subject
- 90 Foregrounds in landscape
- 92 Creating space
- 96 Working from photographs
- 98 Composing a still life
- 102 Backgrounds in still life
- 104 Composing a portrait

108 PROBLEM AREAS

- 110 Trees and foliage
- 114 Winter trees
- 116 Cast shadows
- 118 Sky and clouds
- 122 Still water
- 126 Moving water
- 128 Snow scenes
- 130 Painting buildings
- 134 Painting people
- 136 Painting flowers
- 140 Surface shine and reflections

142 Index

144 Credits

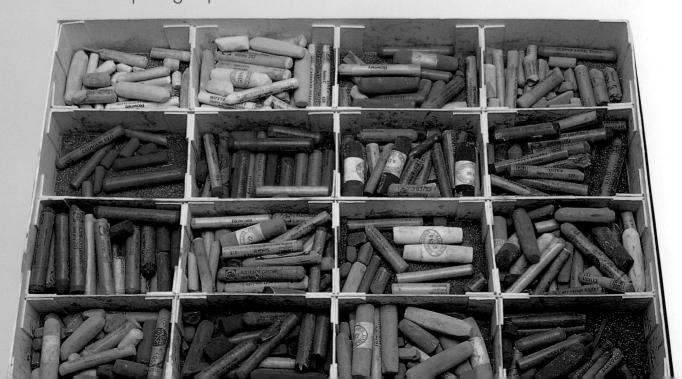

FOREWORD

As a child in a small rural school I learned to write and draw with a piece of chalk on a slate, watching my teacher using coloured chalks on her big blackboard. My love of pastel was born at this same early age, when I was given some coloured chalks and black paper to draw on. I was also given wax crayons which, as I soon discovered, did not mix with pastel and were not suitable for drawing on the slate – my attempts to do so provoked the wrath of my teacher. But this was an important first lesson which eventually led me to experiment with both chalk pastel and oil pastel, a relative of the wax crayon.

At college I learned about the history of pastel painting in Europe, and was introduced to the work of the medium's great exponents – Rosalba Carriera (1674–1757), Maurice Quentin de la Tour (1704–1788), Jean-Baptise Perroneau (1715–1783), Jean-Siméon Chardin (1699–1779) and the greatest of all – Edgar Degas (1834–1917). These remain my favourite pastellists. Chardin's late self portraits are crisp and vigorous, showing that pastel does not have to be soft and smudgy, while Degas' dancers and studies of nude and semi-nude women washing

and bathing are wonderful examples of what can be achieved by handling the medium with energy and sensitivity. The other inspiring things about Degas' pastels are his daring use of colour and his willingness to experiment – he used pastel in new and innovative ways.

For me, the abiding attraction of pastel is its closeness to drawing. A painting in oil or watercolour usually begins with a line drawing, but in a pastel picture there is no great jump from one stage to the next; it develops from being a structure of lines, gradually acquiring more pastel until the artist feels enough has been said. Sometimes this may mean a very densely worked pastel painting built up in several layers, but sometimes the covering is relatively light, and a finished picture will still show the paper colour. Each artist has a different way of working because the medium is so versatile. It can be used on a wide range of supports – papers, boards and textured surfaces – which all add something to the finished painting.

To present the possibilities of pastel painting in an easily accessible way this book has been

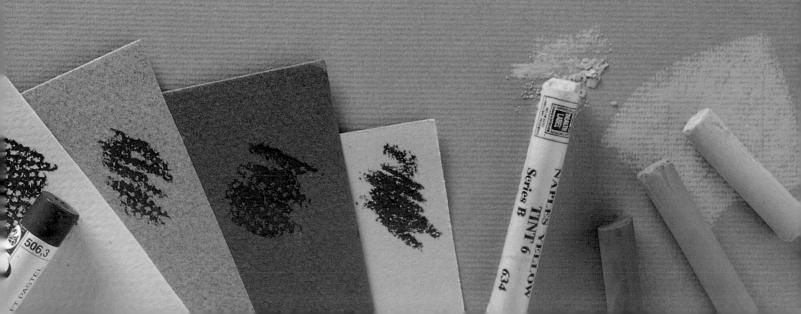

organized into four sections, starting with an introduction to the materials. This shows the different types of pastel, papers and boards as well as giving advice on deciding a size and format for your paintings and hints on looking after your work.

The second, third and fourth sections, however, form the central core of the book. These are arranged as a series of question-and-answer "minichapters", each one highlighting a common painting problem. In each case, a typical beginner's picture is shown in juxtaposition with one or more by an established artist, demonstrating individual ways of solving the particular problem. The accompanying text helps you to avoid obvious mistakes by suggesting useful procedures.

Section Two deals with the theme of colour, explaining basic colour theory, colour relationships, and methods of colour mixing. Section Three is concerned with the compositional aspect of picturemaking, while Section Four looks at some of the problems you may encounter in specific subject areas. Altogether, the book offers a blend of practical advice and inspiration. It is designed for dipping into and consulting when you feel the need for guidance, and I hope it will encourage you to use the medium with confidence and enjoyment.

Hubrit

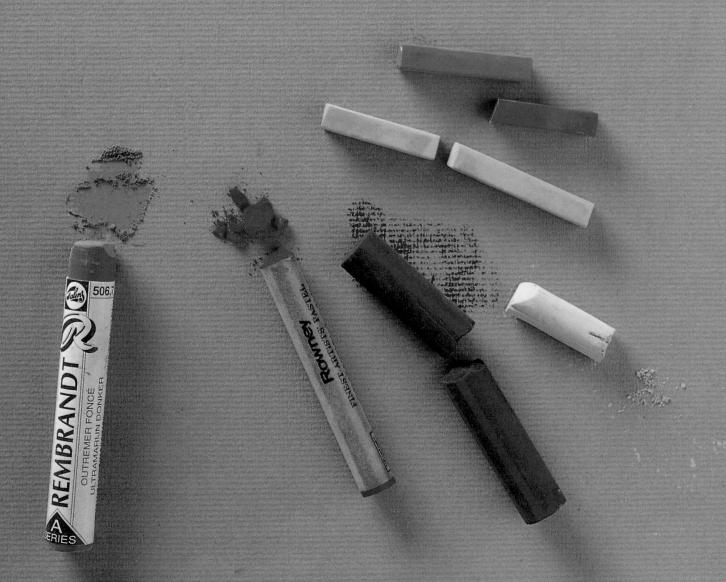

making a START

One of the most attractive things about pastel painting is directness and immediacy. There is no need for elaborate preparations; a piece of paper, a box of pastels and somewhere to work are the only requirements initially. There is something uniquely satisfying, too, about the act of applying the colour. There is no intermediary such as a brush; you hold the colour itself between your fingers and

you make a mark.

But making the first mark can seem a frightening step into the unknown, so it is a good idea to play with the medium for a while, using a sketchbook or small pieces of pastel paper to experiment on, before you settle down to an actual subject. This chapter will guide you along the path towards making your first real paintings by helping you through the various

choices available to you. When you begin the process of picturemaking you will have to consider the paper surfaces, choose the pastel type and colours, and decide what size you want to work. One piece of advice I always give my students is never to throw anything away for at least a year; this enables you to see how much you develop.

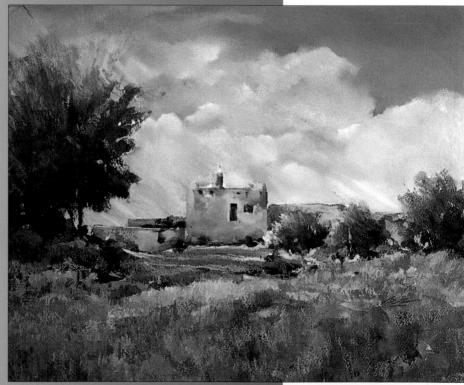

Mesa Quiet

In this landscape, the artist has used a feathering technique laying light diagonal strokes over different colours to give a feeling of mixed foreground flowers.

Why is it that even a simple subject is so difficult to keep under control?

the PROBLEM

Starting with a new medium is exciting, but it can also lead to problems because you are trying to do two things at once - learning to handle the medium and dealing with the subject. The technical problems can obscure what is really important - the way you see the picture. It is essential to be patient and accept that all artists learn a great deal from their mistakes.

the solution

Like writing a diary, picturemaking benefits from what is left out as much as from what you put in. When you deal with any subject you must not take on too many tasks at once. The painting illustrated here is simply realized, with no unnecessary detail to distract from the striking composition. Too much attention to surface detail would weaken the decorative effect of the colour. As you become more experienced with pastels the initial nervousness and preoccupation with handling the medium will give way to the kind of enjoyment that the artist conveys so clearly in this pastel painting.

Perhaps you have tried to include too much, losing the essence of the subject.

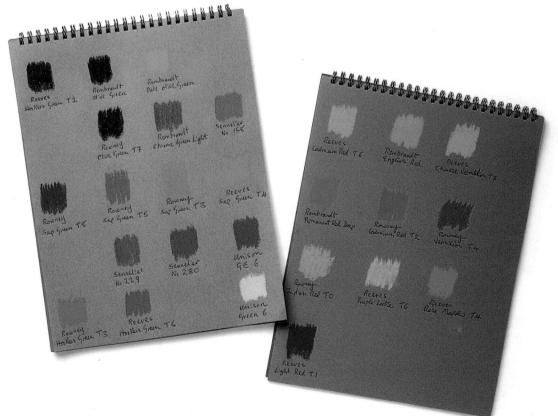

Keeping a sketchbook

A sketchbook is an invaluable tool for the artist. Not only is it essential for making studies of the things that interest you but it also is a place to try out techniques. You can keep all your visual notes and experiments and refer to them when you need to. So that you can compare the effect of different colours and make comparisons between brands of pastel it is useful to keep a record of the colours you use in a sketchbook.

pastel TYPES

How do I decide which type of pastel to use?

the PROBLEM

For a beginner, the choice of pastel types can be problematic. Basically there are four kinds - soft pastels, hard pastels, pencil pastels and oil pastels. The first three are compatible and can be combined in the same picture. Oil pastels are the odd ones out, and cannot be used with the others. Oil pastels are greasy, because oil and wax are used in their manufacture, while the other three are "chalk" type pastels, relatively crumbly and dusty. So, perhaps the first decision to be made is whether to use oil pastel. This medium builds up very quickly into a rich surface, which can be moved, smudged and scratched into for some considerable time after application because it dries slowly, rather like oil paint. Soft pastels also build up quickly, and can be smudged and blended after application. Hard pastels and pencil pastels are more like drawing media, and lend themselves to line work.

the solution

When choosing your pastel medium, you will need to have some idea of the job you want it to do. If portability is important, for example if you are sketching outside or taking pastels on a vacation where you need to travel light, a tray of pastel pencils could be the most suitable. If you attend a life-drawing class, a set of hard pastels would be very useful; these are ideal for line work, but can also be used broadly on their side to make sweeping strokes. They can also be erased reasonably well. Another function of

Pencil pastels are ideal for sketching.

Hard pastels are more portable and robust than soft, but have a more limited color range.

Soft pastels and oil pastels are best for fully worked paintings.

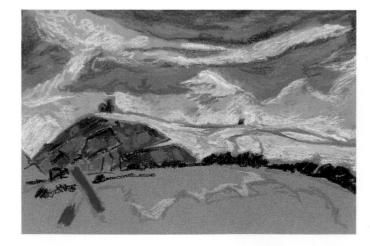

Soft pastel Soft pastel is a rich medium that crumbles easily and creates dust.

Working down the picture, from top to bottom, helps to avoid accidental smudging.

Hard pastel Because hard pastels are firmer, they lend themselves to a more linear

approach. They are ideal for sketching, but can also be used to build up rich color. hard pastels and pastel pencils is to lay down an underdrawing onto which you can then build with soft pastel, and many artists have some of these in addition to soft pastels. Some artists do work outdoors with soft pastels, making use of the richness of the medium and its speed of application.

However, the drawback is that they are very fragile, so you will need to protect them against knocks, and you will have to carry your completed work carefully to avoid smudging. Soft pastels are an ideal studio medium; working indoors allows you to spread out your pastels in an orderly manner on a table. There is a much wider range of colors available in soft pastels than in any other pastel type. All the chalk pastels, particularly soft ones, need to be fixed or protected in some way, because the pigment easily falls off the paper. Oil pastels, being greasy rather than dusty, do not need fixative and are less prone to accidental smudging than the others, so they can also be useful for outdoor work.

Drawing or painting The other factor that will help you make a choice is your own artistic interests. If your inclination is toward sketching and working on a relatively small scale on a sketchpad, you will find hard pastels and pencil pastels the most useful. If you are more interested in building up more complete pictures in full color, and like to work relatively large, soft or oil pastels are the best choices. If you are used to oil paint or are hoping to use this in the future, oil pastels are ideal, because they behave in much the same way, but soft pastels—pigment held together with a minimum of chemical binders and extenders—also enable you to produce richly colored and painterly effects.

Oil pastel Oil sketching paper is a good surface if you want to blend oil pastels.

Here, blends were achieved by working colors over each other.

The pastel touch

Often artists choose one medium rather than another because they prefer its "feel" and the way it handles. If you enjoy pushing your pastels into the paper, and sliding colors into and over each other, then oil pastel may have the right feel for you. But you may prefer the touch of soft pastels, which release a lot of color immediately. Hard pastel offers more resistance and needs to be used more firmly, and pencil pastels feel like drawing pencils, only grittier.

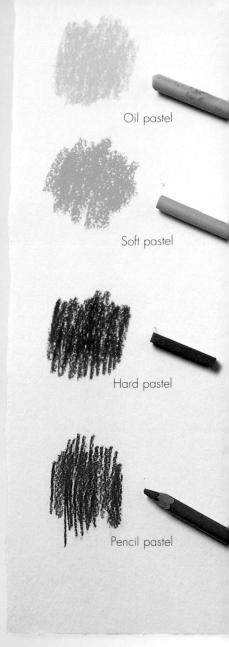

Pencil pastel This drawing shows the delicacy of pencil pastels. They are very useful

for making studies on-site, since they are less prone to breakage.

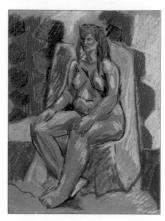

Soft pastel over acrylic

This painting was made in soft pastel over an acrylic underpainting on heavy watercolour paper. The paper was coloured all over with transparent green acrylic and then the largest dark areas were blocked in with greygreen. Soft pastel was used to complete the image, with quite a lot of the sharp green underpainting left showing.

Using soft and hard pastels Here both soft and hard pastels have been used, on top of a grey acrylic ground. Most of the surface was covered with one layer of soft pastel, with hard pastel used to complete the picture. To succeed, the layer of soft pastel must be thin.

Mixing pastel types As has already been said, oil pastel is not compatible with the chalk pastels, but soft, hard and pencil pastels have similar characteristics, and can be used together. So don't worry if someone has given you a set of hard pastels when you already had soft; you will find a use for both. There are other media that are similar to pastel also, such as charcoal and conté crayon – the latter is basically a type of hard pastel.

There are many good reasons why you may want to mix pastel types, or bring in other drawing media. I have already mentioned the use of hard or pencil pastels for making an underdrawing, but you can also use them for small details or to give sharp edges to shapes made with soft pastel. You can "cut" lines through an area of soft pastel with a pencil pastel, but working in hard pastel on top of soft will only work if you have not built up the soft too much; the same applies to conté crayon. Similarly charcoal works very well with hard pastel but will not draw over soft pastel very readily. It is also much less black than conté or pastel black, which makes it a good alternative to pastel pencil for lightly sketching your composition before beginning in colour. Charcoal is also handy for modifying a pastel colour that appears overbright.

Pastel and paint Pastel can also be used in combination with paints. Instead of using hard pastels to work out your composition for a soft pastel painting, you can block in your main shapes with watercolour, gouache or thin acrylic. You must use watercolour paper for this method, not pastel paper, as the water could cause buckling. Oil pastel also works on top of water-based paints, and also over oil paint, and can be worked into oil paint while it is still wet. Oil-sketching paper is a good surface for an oil paint and oil pastel combination.

It is a good idea to carry out tests when you are mixing media or pastel types, and keep them by you to remind you of the kind of effect you are likely to achieve. The chart illustrates some possibilities but you could experiment much further.

Mixing pastel types (soft, hard, pencil pastel and charcoal) The

chart opposite shows a variety of the effects that can be achieved by mixing pastel types. It is useful to see them arranged in this way because it shows the differences between overpainting with the various types. The idea could be taken further, for your own future reference, with many different combinations. For many artists, the mixing of hard and soft pastels is an important part of picturemaking methods, with soft pastel providing rich buttery colour and hard giving a sharp line.

Mixing oil pastels Oil

pastels can't be mixed with other pastels. In the chart opposite we show the effects to be achieved from laying oil pastels on top of each other, and on top of acrylic.

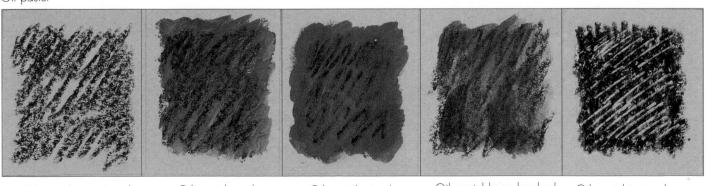

Oil pastel on oatmealcolour paper

Oil pastel on dry acrylic paint

Oil pastel mixed into wet oil paint

Oil pastel layer brushed out with turpentine

Oil pastel in two layers, the top layer scraped

colours do Lneed? There seem to be so many.

How many pastel Begin with one of the manufacturer's starter sets and build up more colours gradually. Or choose your own selection; all pastel can be

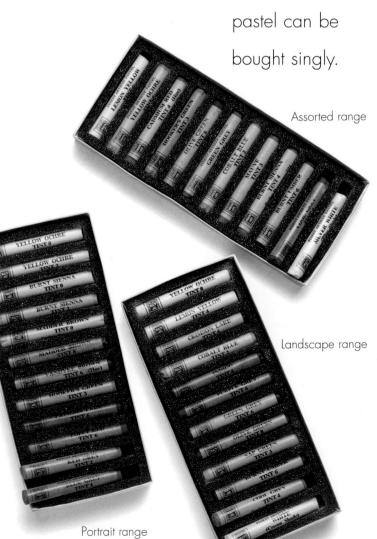

the PROBLEM

Pastel manufacturers do produce huge ranges, but you do not need many to make a start. Deciding which ones you need, however, can be difficult. It helps to have some idea of the kind of subject you are going to tackle - landscape painting, or portrait, flowers, still life and so on - and, of course, which kind of pastel you are going to use.

the solution

All the principal manufacturers of pastels sell various starter sets. Daler-Rowney Artists' Soft Pastels, for example, are available in boxes of 12 colours with different selections for landscape and portrait, and one "assorted". These sets are ideal for beginners, and you can gradually add to them as you discover the other colours that you need. For the more ambitious, there are also larger selections containing 72 and 144 colours.

Making your own selection If you don't want to be limited by a manufacturer's selection there is no reason why you should not choose your own. It is a good idea to keep your pastels in groups, or "families", to which you can add.

Ranges available By far the greatest range of colours is available in soft pastels, which is one reason why they are preferred by artists whose approach is painterly rather than graphic. Daler-Rowney sell almost 200 colours, while in their hard pastel range they have less than 50. A set of pastel pencils, sold in a tin, usually contains no more than 36. Similarly oil pastels have a relatively limited range of colours, but manufacturers are now producing more to meet the growing demand for the medium. Also, colours can be blended very thoroughly with turpentine or white spirit which extends the possibilities.

Tints An important thing to realize about pastel colours is that they are made in different "tints", that is, one blue

Starter sets Manufacturers' starter sets are a very convenient way of finding your way into pastel painting. They are obtainable in Portrait, Landscape and

Assorted ranges. Necessarily they are very basic sets and are not intended to be more than an introduction to the medium

can be very much lighter than another although both are based on the same pigment. Pale tints are made by adding white to the colour, and dark ones by adding black. This can be confusing, as the addition of black can change the appearance of the colour, so that what may be labelled as red actually appears brown, and a dark tint of yellow as green. Tints are denoted in different ways according to the manufacturer.

It is not necessary to have all the tints of each colour, but as you gain experience you will discover the tints that will be most useful for you. It is a good idea to have a selection of the paler blue tints if you are painting a lot of skies, and some of the darker greens for foliage and grass. For a portraitist a selection of tints from the pale end of the scale in raw sienna, madder brown, red grey and indian red would be very useful.

Compatibility You need not stick to one range; you may find that some "special" colours can only be obtained by shopping around. All soft pastels are compatible, though the names differ, so don't try to match colours in one make with those in another by name only. A sap green is likely to vary from make to make as will many others, and in some ranges may go by a different name. Also, although there is theoretically no problem mixing different makes together, you may encounter differences of consistency.

Other pastels A few conté sticks are a useful addition to a set of pastels. Traditionally they come in sanguine (a redbrick colour), black and white. But a wider range of colours is becoming available. They are a hard pastel type and very useful for drawing a basic composition before adding soft pastel, and they can be used in their

own right or with other hard pastels. They do not mix with oil pastels which are greasy rather than soft and dusty, but they can be used with oil paint.

20

Conté sticks

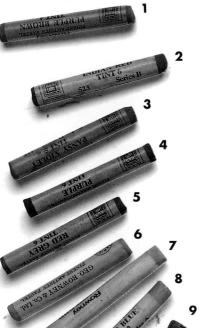

A basic palette This is a good range that will cover most eventualities: portrait, landscape or any other subject. The selection includes several pale tints which are invaluable when you need to put in subtle lights in portraits or still life paintings. Obviously every artist discovers his or her own preferences and you will find colours that you will want to add.

10

- 1 Purple brown tint 4
- 2 Indian red tint 6
- **3** Pansy violet tint 5
- 4 Purple tint 6
- 5 Red grey tint 6
- **6** Blue green tint 5
- 7 Grass green tint 6
- 8 Cobalt blue tint 2
- 9 Ultramarine tint 6
- 10 Yellow ochre tint 2
- 11 Lemon yellow tint 6
- 12 Cadmium yellow tint 4
- 13 Cadmium orange tint 6

- 14 Poppy red tint 6
- 15 Cadmium red tint 1
- 16 Rose madder tint O
- 17 Crimson lake tint 6
- 18 Intense black
- 19 Cream white
- 20 Silver white

17

Additional equipment and materials

There are a number of useful items to add to your pastels, some vital for pastel painting, others more or less important depending on your preferred methods of working.

- 1 Drawing board This is essential to work on. Look after it carefully when not in use or it will get dented or scored, marks that will show through on to your paper.
- **2 Gummed paper strip** If you tint your paper with watercolour or acrylic it is advisable to stretch your paper using gummed strip (see page 24). Some artists prefer to use white acid-free strip.

3 Book of different coloured pastel papers

This is a useful introduction to some of the many different coloured papers available, allowing you to find out which colours you prefer to work on

4 Charcoal pencil This has a compressed charcoal "lead", and is very useful for lightly drawing out your composition.

5 Charcoal sticks

Charcoal can be used for indicating the composition and it can also be used in conjunction with pastel as a soft black (see page 73).

- **6 Clutch eraser** This can be used for precise erasing and as a drawing implement in its own right by cutting into pastel areas to reveal the paper colour (see page 109).
- **7 Putty rubber** This works best when rolled in the hand to make it slightly warm and

is good for lightly lifting off pastel. Some artists always keep one of these erasers in a pocket so that it is always warm and ready to use.

- **8 Sponge** Besides being used for damping paper when you are stretching it, a sponge can also be used to soften and smudge your pastel.
- **9 Cotton buds** Another tool for softening pastel, particularly useful with oil pastel, and can be dipped in turpentine (see page 35).
- **10 Cotton wool** Useful for blending pastel colour.
- 11 Stump This is made from rolled and compressed paper and is used for blending and partial erasing.
- 12 Protective mask If you are working in a poorly ventilated space and/or doing a lot of erasing you will create a lot of dust. Modern pastels do not contain highly toxic pigments, however it is not a good idea to breathe in dust, and these masks are a useful protection.
- **13 Aerosol fixative** Most pastellists use fixative spray. But again it is not a good idea to breathe it in. Do your fixing outside or in a very well-ventilated area (see pages 28–29).
- **14 Fixative in a bottle**For use with a diffuser. This creates less toxic fumes but requires practice to get an

even coating.

15 Diffuser This can be used to spray fixative; also to tint paper with dilute watercolour or acrylic before you start; and it can be used to spray colour on to a pastel

painting at a midway stage.

16 Craft knife This has
numerous uses, from cutting
pastels to give them a sharp
edge, to cutting paper.

17 Polythene dust sheet Particularly useful if you are using a room in the house, a spare bedroom or the dining table, a dust sheet collects the dust you will inevitably make.

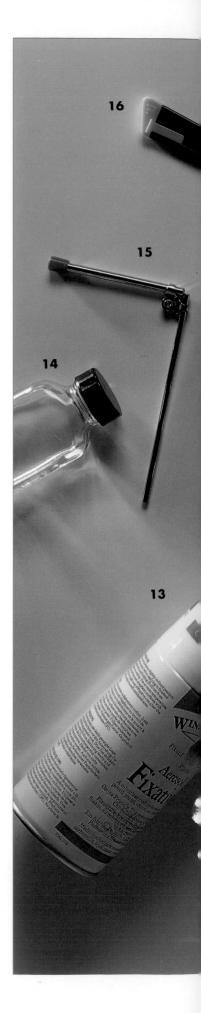

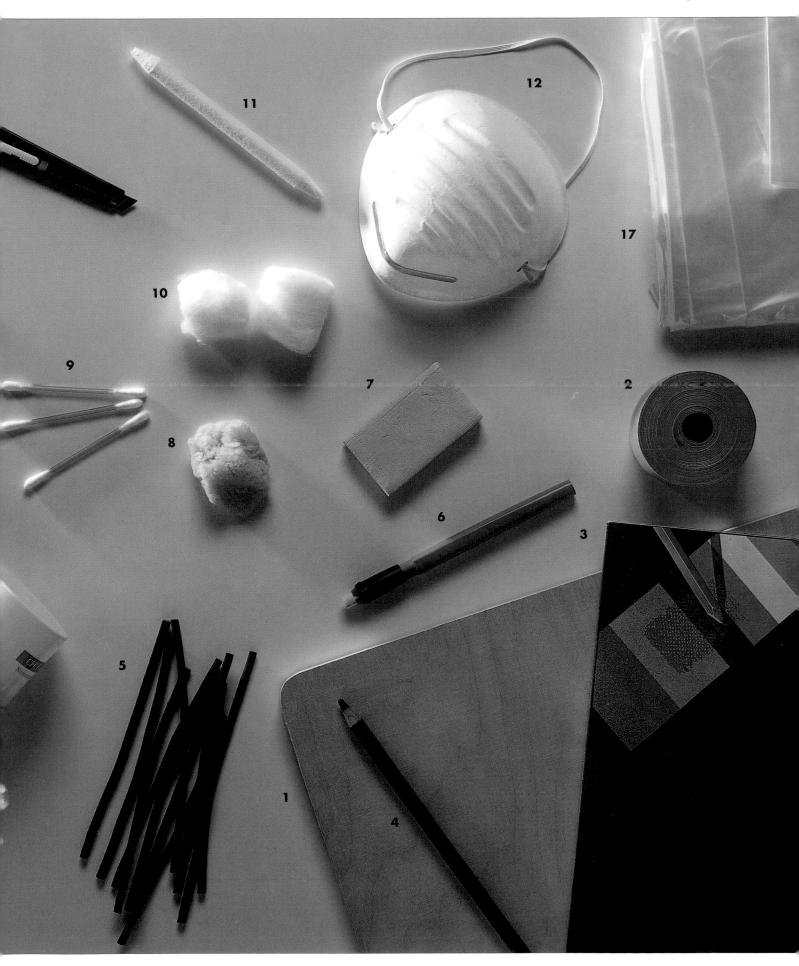

paper colour

Are pastels always done on coloured paper? Why?

Avoid white unless you are sketching with limited colour. Stone colours, cream, dull greens are ideal for figure and portrait. Warm greys, red ochres and maroon are exciting grounds for landscape.

the PROBLEM

There is no law against using white paper, indeed it can work well for some subjects, but it can make unnecessary difficulties; as you can see from the student's picture the white is very distracting. Pastel is not like paint. It sits on top of the paper instead of sinking into it. The grain of the paper means that when you draw your pastel across it you will always have some paper showing unless you press very hard or determinedly rub your pastel into the grain.

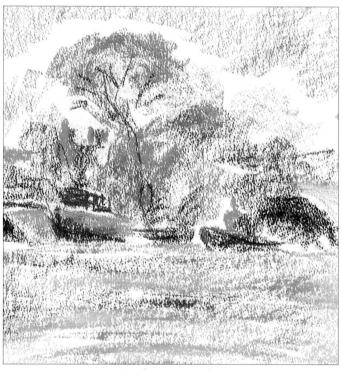

Student's version

It is a good idea to choose a paper that is appropriate to your subject matter and the overall colour composition. The student's painting, with its warm yellow-browns and deep purply blues, has lost much of the richness which those colours promise. The white breaks through, spoiling the depth of the purples and breaking the surfaces described by the ochres.

the solution

When you choose a paper, think about the kind of colours that you are going to use, and try to view the paper as the first step in building up the picture. Some of the paper will nearly always show, and is an integral part of most pastel

Paper colour This is a marvellous range of pastel paper colours including some very bright and intense colours. For most occasions the subtler tints are the most appropriate.

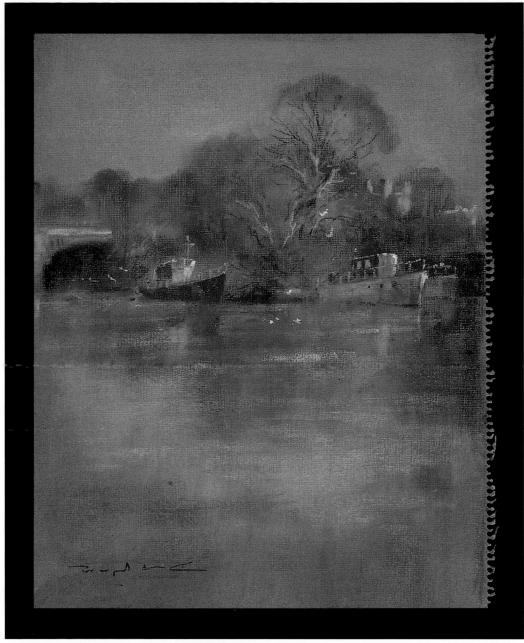

Richmond by David Mynett

pictures - you can see this in the artist's pastel.

The larger art shops stock a huge range of the standard coloured pastel papers (Ingres and Mi-Teintes), but for most paintings it is best to avoid the very bright or very dark colours, as these may influence your pastel colours more than you want. I have a little book of colour samples of my favourite paper which has a range of 28 colours. As I do a lot of work from the nude I tend to use paper that will set off skin colour, usually something fairly cold such as a cool slightly greenish grey, so that I can provide the warmth with my pastels. Working from the landscape may demand a range of papers depending on the time of the year and the type of countryside. I find a

pale pink or a pinky grey are good for the lush greens of the English countryside, but a Mediterranean scene might demand something stronger to contrast with the brilliant whites of houses and so on. Here I might even choose a maroon colour, against which dry-looking ochres, grey olive tree trunks and foliage would contrast strongly; this would also force me to use strong, light pastel for the sky. I like to use a paper colour that contrasts with my overall colour scheme, though some artists adopt the opposite approach and use a paper that blends in with it. This works well if you intend to leave large areas of paper uncovered. You might, for example, leave much of the sky in a landscape as blue-grey paper.

This is often a necessity, as it allows you more say in what you work on. Using watercolour, gouache or very thin acrylic you can mix exactly the colour you want. You

Using different coloured papers This chart demonstrates how colours are influenced by those around them. The first vertical column shows eight colours on white paper. The same colours are then repeated on eight different coloured papers. As we can see, for instance in the line of blues, a colour can move from hard and

dark to a soft shimmer, entirely because of the paper colour. On white paper we see the maximum tonal contrast while on the darkest brown the blue is virtually the same tone – hence the shimmer. The coldness of the blue brings out the reddishness of the brown.

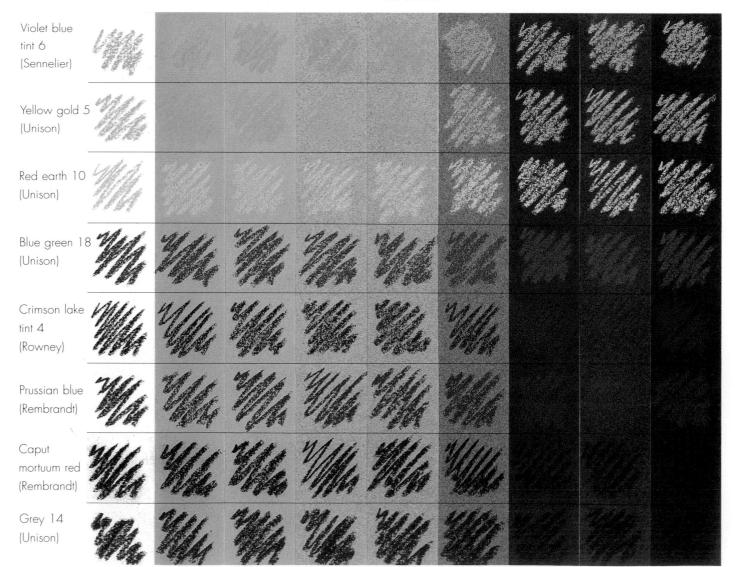

can also paint blends, have different colours in different sections where you want them, and also apply your colour as evenly or unevenly as you think fit. Colour does not have to be put on with a brush. It can be spattered on with an old toothbrush or sprayed with a diffuser.

Watercolour papers Tinting your own paper also gives you more leeway in the choice of paper surfaces. Many people dislike the rather mechanical and even texture of the standard pastel papers, and prefer to use watercolour paper, which provides a choice of three different textures – hot-pressed, (smooth), cold-pressed (medium) and rough. Rough is too heavily textured for most work – whatever colour you tint it will show through your pastel. Smooth paper is quite difficult to work on with pastel, but tinting it with gouache provides a little extra texture while leaving the surface smooth enough for detailed work. The standard cold-pressed has a good workable tooth without being too pronounced.

Alternative colouring methods You don't have to use paint; some artists stain their paper with cold tea. My wife uses diluted Chinese ink on a smooth watercolour paper to produce a beautiful matt grey. If you keep your old fragments of used pastels you can grind them up in a pestle and mortar (or with an old spoon in an earthenware vessel), mix the powder with thin acrylic medium and use that. Be careful that you do not have too high a concentration of acrylic, though, as it will dry too shiny for your pastel to adhere.

Special effects I mentioned the subject of a figure against the light earlier. One way of preparing the paper would be to use paper stencils. You could spray over the whole paper in a pale yellow, using a mouth diffuser, then cut out a silhouette of your figure in stencil paper and spray a dark colour through it. Sprayed acrylic has another possible function. If you want to radically alter the colour balance of a pastel in progress you can spray it with dilute colour. This also acts as a fixative because acrylic cannot be removed once dry.

Methods of tinting paper

Preparing your own coloured papers for pastel painting does not need to be a complicated business. However, unless you use a heavy (200lb) watercolour paper, it is advisable to stretch it first (see page 24) if you are using paint or ink to tint it.

Chinese ink is diluted one part to three parts water and applied with a 2.5 cm (1 in) household brush. The paper absorbs the ink so that the surface remains unchanged.

For an even all-over tint with watercolour ensure that you mix a sufficient quantity so that you don't have to colour match part way through.

To achieve very delicate tinting without mixing white or brushing on a lot of very thin watercolour you can use a diffuser to blow a mist of colour on to the paper.

A diffuser allows you to use stencils, should you want some areas tinted differently. For this image, the fine detail was cut in the stencil with a scalpel.

I like to build up my pastel thickly. What papers are best for this?

If you like to build up thick colour and don't find standard pastel papers adequate, you can prepare your own grounds - pumice powder is ideal.

1 Canson Mi Teintes

the PROBLEM

Soft pastel is such a rich medium that it asks to be applied generously. The problem is that many papers will not hold a thick build-up of pastel as the tooth is not sufficient. The heavier the layers of pastel you want to put down the more abrasive the supporting surface must be. Even the roughest watercolour papers are not rough enough for some pastel painters, who prefer to work on fine-grade sandpaper, or pastel board, which has an abrasive surface made from tiny particles of cork.

the solution

You can also make your own textured grounds, one method being to spray acrylic onto watercolour paper with a diffuser. This will give you a speckled texture, but this is still a fairly subtle surface. Probably the most abrasive surface that you can produce yourself is one made from pumice powder. This can be mixed with acrylic or PVA medium or glue size and applied with a coarse bristle brush. Don't be worried if, when it has dried, it does not feel very abrasive to your fingers. Unless you were very parsimonious with the powder you will find that it provides an excellent tooth for pastel.

For this kind of ground you will need a thick watercolour paper, and it is advisable to stretch it first so that when you apply your coating the paper will not buckle. An alternative support, ideal if you are applying heavy coats of pumice solution, is medium density fibre

Paper types The pastel differing surfaces these papers offer. The pastel board and the flourpaper take the most pigment from one stroke; the watercolour paper requires more pressure to get a dense covering.

Using different textures

Changing the surface that you paint on can open up new possibilities. On some surfaces you will have to work hard to fill the grain or texture provided by your support. Smoother grounds encourage a speedier approach and allow an unbroken line. Opposite are six different supports, each showing how the surface texture can add to the quality of a painting.

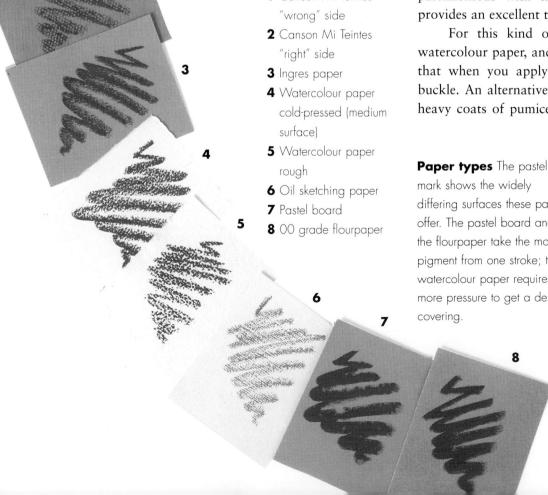

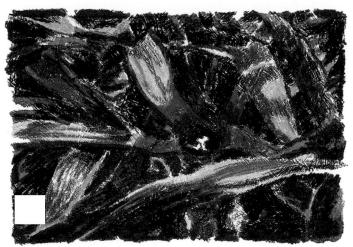

This oil pastel was done on a piece of medium density fibreboard (MDF) primed with

acrylic gesso. The pastel was applied thickly and could be worked into the texture.

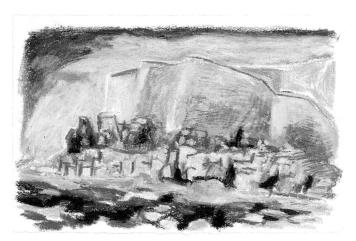

A much smoother surface for oil pastel is a piece of primed watercolour paper. Any

texture then has to be created by using oil pastel itself.

Ordinary brown wrapping paper is a remarkably strong surface to work on. This

picture was done with pencil pastels, and the subtle stripe of the paper is still visible.

Because of its mid-tone, sympathetic colour and tough surface, cardboard is a

pleasant support, but it is not acid free. This piece is in soft pastel.

If you like to use soft pastel thickly an 00 grade glasspaper is a good

abrasive surface. It also erases easily if you use a plastic eraser.

Some artists like to use pastel on a very large scale, and canvas is ideal. This painting

was done on a piece of unbleached Belgian linen canvas.

Stretching paper

Stretching paper prevents it from buckling when you use very wet paint, and it is essential when preparing textured grounds for pastel paintings because you will need to use fairly thick mixtures of acrylic, PVA or size to hold your abrasive.

lay your paper down on a clean drawing board, then use a damp sponge to wet

first one side and then the other. Don't soak the paper.

Allow the paper to expand; this will take a couple of minutes. Then smooth the

wrinkles in the paper towards the edges from the centre.

Tape the paper down with brown gumstrip damped on both sides, then smooth the

strip with a dry cloth and leave the board to dry flat.

board (MDF). This is sold in different thicknesses, and even at its thinnest resists bowing when the coating dries. Hardboard is not recommended, as it warps badly unless reinforced in some way.

Altering machine-made texture If you find the texture of pastel papers unsympathetic – some of them make me feel as if I am looking through a net curtain at my subject – you can try using the "wrong" side; in both of the standard pastel papers this still has enough tooth to hold the pastel. But if it is texture that appeals to you why not stretch up the mechanically impressed paper and add some more texture of your own to break up the monotony? Again use pumice powder or even a relatively thick coating of gouache.

Impasto paint The important thing to remember when building a surface suitable for pastel is that no matter how much texture you have pastel will not adhere if the paint is glossy. Gouache is an ideal medium as it is perfectly matt. The disadvantage is that you cannot build it up very thickly without it cracking. If you want a highly impasted surface you will have to use acrylic well mixed with a good matt medium such as gel medium, which thickens the paint.

Whatever is suitable for oil paint as a support. The most convenient surface is oil sketching paper, which has a simulated canvas grain, or you could use real canvas, sticking it down with size onto a piece of board and then priming it. This makes a robust surface to work on. Oil pastel will adhere to smoother surfaces than chalk pastels so there is no particular need to build a textured surface when you want to apply the colour thickly, but you may find you like the effect. An old oil painting with an impasto finish makes a good surface, but make sure it is thoroughly dry. As with chalk pastel you could build textures with pumice powder, but using oil- or resin-based mediums such as alkyd, polyurethane or cellulose to bind it.

Applying texture

You may decide that you want to give your paintings a stronger physical quality. This can be achieved by putting down a textured ground.

Basically you need two ingredients – an abrasive (gritty substance) and a binder. Fine sand, pumice powder, gesso powder, brick dust all make a good fine grit, which you can bind with a small amount of PVA or acrylic medium (preferably a matt acrylic gel).

You do not need a lot of sand to give texture, and it should be the finest you can find. If you use too much it will be very difficult to spread.

The way in which you put on the paste will also give a texture. The picture shows it applied in parallel strokes which might be useful if you were painting buildings or a landscape with simple receding lines of hills.

If you use a fairly stiff acrylic paint, it can be spattered on to paper with a toothbrush. This gives an uneven scattered dot which makes a gentle tooth to work on.

Much of this painting's impact derives from the richness of the soft pastel medium. This is accentuated by the texture of the ground which breaks through the colour, particularly where it is darkest.

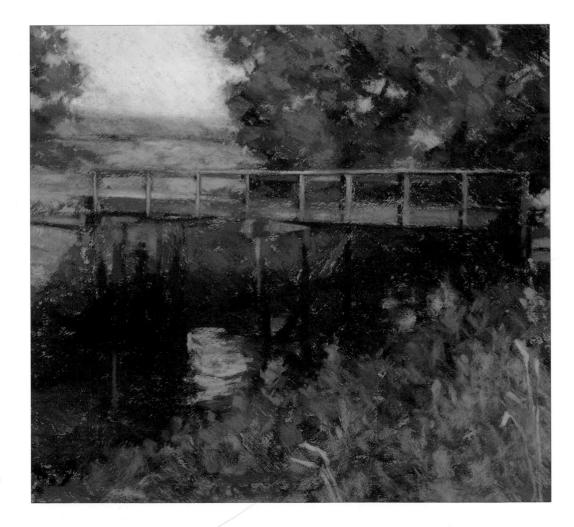

choosing paper size

I haven't painted
with pastel before
what size should
I work?

the PROBLEM

Whatever medium you use, deciding on the right size for a picture can be a problem. Most beginners work on a modest size to avoid taking on too much, but the reasons for choosing size when working in pastel are likely to be different from choosing a painting board. In oil or watercolour you can use smaller brushes, but with soft pastels there is a limit to the fineness of mark you can make, so you should avoid very small pads of paper.

the solution

This is the key to the problem – the size of mark that your type of pastel provides. If you are using pencil pastels, for example, it will be a very laborious business working on an A1 sized sheet. Pastel pencils are ideal for small-scale work and particularly useful when working in a sketch-

Pick a size that
suits the kind of
pastel you are
using. Soft pastel
makes broader
marks than pastel
pencil or hard
pastel, so is not
well suited to small
sketchpads.

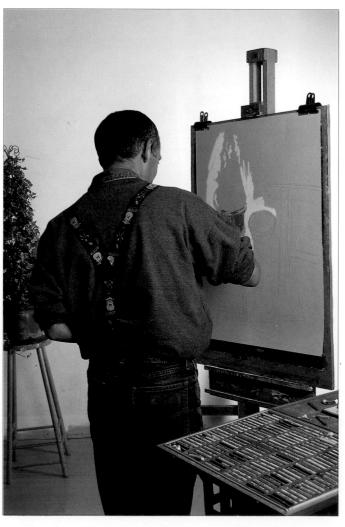

Working at an easel

When you use an easel, you can use your whole arm to draw with, bending at wrist, elbow and shoulder, in order to make larger marks.

Broad strokes and small strokes Working on a large scale enables an artist to use a wide range of pastel marks, from the broadest side strokes to the finest details.

Also, the way in which you hold and apply your pastel will differ from working smaller. On a large board you can use your whole arm to make sweeping strokes.

This detail from a smaller pastel drawing was made using quite fine linear marks, using mostly hard pastel.

book out of doors. You may find the following helpful in making decisions about size:

Indoors or out? If you are going out to paint, particularly if you are going far, you will need to keep things portable. So A2 is probably the largest practical size. If you are out in your own garden you could work larger as you won't be carrying things so far. Obviously there is less of a problem indoors so here your choice will depend on other factors.

Which kind of pastel? Soft pastels are not well suited to very small-scale work simply because of the relatively broad marks these make, so it is not advisable to work smaller than about A4 size. Hard pastels, coloured conté and pastel pencils can be used for pictures approaching the miniature.

The subject Now you need to think about the appropriateness of size according to your subject. If you have not used pastel before then it is unlikely that you will want to work larger than life size. So if you are working from a still life, get close enough so that you can see it clearly and then you can work "sight size". This means that when you hold out a straight edge to measure you transfer that size directly to your paper. If you do this, you can simply choose the paper size that fits – literally – the subject. You can work sight size for any subject, and it does help you to draw accurately, as you don't have to scale things up or down. This can also apply to landscape and portrait. With more experience, and when you begin to draw and design your compositions more confidently, you will probably work larger than sight size.

Working "sight size" By sliding your finger up and down a pencl you have a simple marking device. If you transfer that measurement directly to your paper, you will have a "sight size" drawing.

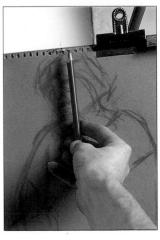

looking after your work

Is it best to fix my pastels? I have heard that some artists don't do so.

the PROBLEM

Pastel paintings, particularly heavily worked ones in soft pastel, are notoriously dusty, which makes them difficult to handle and store. But there are indeed artists who avoid fixative, and there are reasons for this. If you work on a dark or mid-toned paper and use light colours, the fixative will "knock" the pale colour back into the paper and darken it. When colour has been built up in thick layers there is more potential danger, as the fixative may cause the colours underneath, including corrections, to bleed through.

the solution

Oil pastels escape this difficulty as there is no need to fix them. They do remain soft for some while but they are much less likely to lose surface colour than soft pastel.

Some pastel purists insist that fixing spoils the surface of a pastel painting as well as darkening the colour, and it is true that you may sacrifice the fine dusty bloom of a freshly completed pastel. However, beginners are advised to fix their work, and as long as you don't overdo it you are unlikely to see any adverse effects. Overall you have to weigh up the disadvantage of some loss of delicacy against the advantages of being able to store and carry a reasonably stable painting. So fix as lightly as you can to

Don't fix your work
too heavily or you
may lose some of
the delicate effects.
Protect your
finished pictures
by interleaving
them with acid-free
tissue paper.

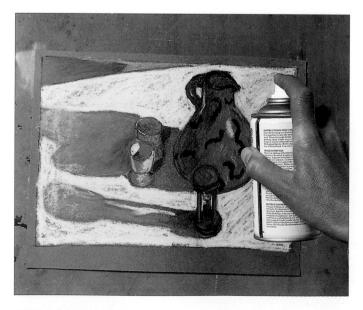

Fixing from the front To get an even coating of fixative you should hold the

spray can about 45 cm (18 in) away from the picture and work your way down.

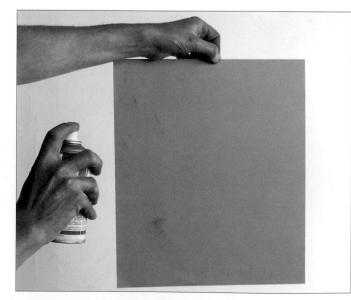

Fixing from the backFixing from the back will only stabilize the layers nearest to

the paper. The top surface will remain easy to smudge.

hold the surface and then – if you have been working on location – transport your pictures carefully between sheets of tissue and card.

Sometimes it is helpful to fix your painting at various stages as you work. If the build-up of pigment prevents you adding further colours or defining details, a light spray will make the surface more manageable. Let the fixative dry before continuing.

Storage It has to be said that even quite heavily applied fixative does not afford total protection against rubbing and smudging, so you will need to take care of your finished pieces. The ideal place to keep them if you have the space is in an architect's plan chest between sheets of tissue paper. Acid-free tissue is best for long-term conservation as it is less likely to discolour and stain any pale colours in your pastel. Newsprint can be used, but it discolours quite quickly and is also more likely to scratch your pastel if it gets a crease in it.

Not everyone has room for a plan chest, of course, so an alternative is to keep your pictures in folders – under the bed is a good place. It is vital to keep them flat, because otherwise the paper will slowly slip down, bending and rubbing as it does so, even in the firmest folder.

It is not a good idea to keep your finished pastels in transparent plastic presentation sleeves. These are fine for showing your work to someone, but in the long term you will find that static and/or humidity causes the pastel to travel onto the inside of the plastic sleeve resulting in a deterioration of the work.

Framing If you decide to frame an unfixed pastel make sure to give it a firm bang to dislodge any loose particles before you take it off your drawing board. If you don't do this you will find that when you hang the picture you have a sprinkling of pastel dust on the bottom edge of your freshly cut mount. You must have a mount, as this keeps the pastel painting away from the glass; if the two are allowed to touch you will have the same problems as with plastic presentation sleeves.

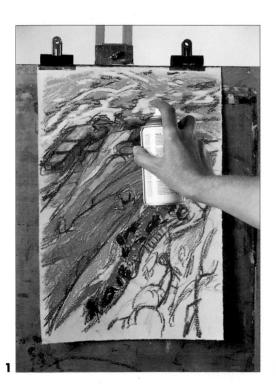

Fixing at intervals

- 1 You can apply light layers of fixative at successive stages of the drawing.
- 2 Use the fixative sparingly; don't overwet the surface. Wait until the fixative is dry before going on with the painting.

COLOUR

If it is drawing that defines and describes then it is the job of colour to provide intensity and feeling. There are many scientific theories of colour, some of which rely upon the scientific analysis of light, but the following chapter will present you with some practical help and examples of how colour may be used. The first ingredient is the pastel itself, and you will need to collect a good range of colours and keep them ordered so that you can find them easily. You will need each of the three

primaries and three secondaries but because there is no such thing as a perfectly pure pigment you must be sure to have at least two hues for each colour. You will need a red that tends to orange as well as one that tends to purple, a blue that tends to green and one to purple, a yellow that tends to orange and one that tends to green. What makes pastels different is that you can amass scores of 'tints'. This enables you to add a tint to a picture without having to mix or blend.

Bloomin' Paradise

Kay Polk has used brilliant pinks and oranges to create a shock of colour. She has not been afraid to use the strongest of hues.

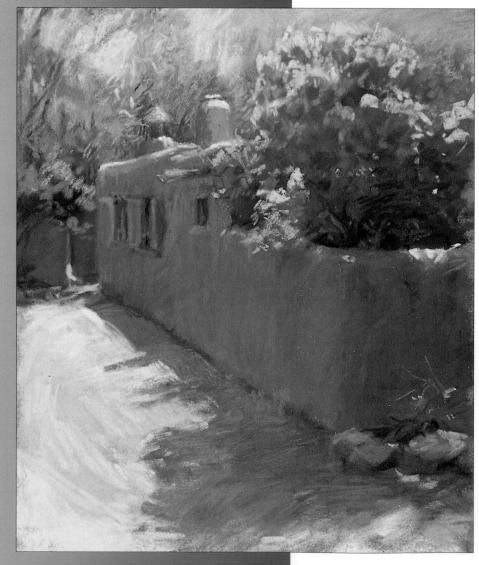

Why do I get a brown instead of an orange when I mix red and yellow pastel?

the PROBLEM

A lack of understanding of the basic principles of colour can make the process of colour mixing unnecessarily difficult. All the secondary colours – oranges, greens and purples – can be vivid or muted depending on the primary colour hues you choose for the mixtures. Recognizing which colours are warm and which are cool is the first step on the road to accurate colour mixing.

the solution

It is a good idea to familiarize yourself with the basics of colour theory so that you will be prepared for any colour mixing difficulties that may arise. It is not complicated, and can be demonstrated quite easily with simple diagrams such as colour wheels.

You must find the warmest red and yellow to make the best orange.

Primaries and complementaries The

three primary colours are red, yellow and blue, so called because they cannot be made by mixing. The colours that appear opposite these on the colour wheel are called complementaries. Mixtures of two primaries produces a

secondary colour: blue and yellow make green; red and blue make purple; red and yellow make orange.

Tertiaries are made from mixing a primary and a secondary – brown–green from red and green; grey from mauve and yellow.

6-colour wheel showing primaries and tertiaries.

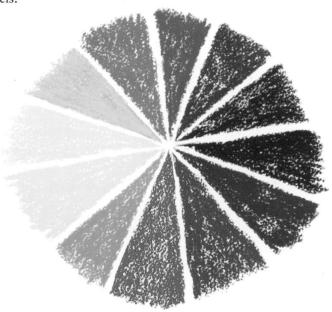

12-colour wheel showing primaries, secondaries and some tertiaries.

Colour temperatures It is

in the primary colours that artists find that their pigments are not absolutely primary. This can be easily demonstrated by trying to mix an orange and a purple with the same red hue. You will find that it will make either a good orange or a good purple. Yellow is the warmest

colour so the orange-red is the warm red, the purple-red is the cool. In the yellows, yellow-orange is warm, the yellow-green is cool. The terms warm and cool are relative – as green tending to yellow is a 'warm' green, but yellow tending to green is a 'cool' yellow.

colour MIXING

My painting looks
crude; how can I
make the colours
more subtle?

Keep blending and smoothing to a minimum. Instead, mix colours by overlaying one on another

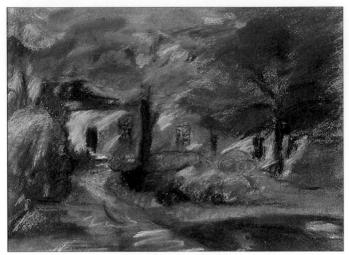

Student's version

the PROBLEM

Beginners are sometimes told that pastel colours can't be mixed, and you have therefore to have a huge range of pastels to achieve any subtlety of colour. But of course pastels can be mixed – the difference between paints and pastels is that paint is mixed on one surface and transferred to another, while with pastels the mixing is done on the picture surface, by laying one colour over and into another. It is true that some professional pastellists do work with a large range of colours, but even so they will usually mix as well. The student has made an uneasy compromise, using pure colour in places and attempting mixtures in others, but overworking the pastel so that the effect is clumsy.

the solution

There are several tools that can be used for mixing colours by blending them into one another: a "stump", which is a cylinder of compressed paper sharpened to a point, the cotton buds you buy in a chemist's shop, a piece of cottonwool, a soft eraser, a sponge, and last but not least, fingers. But the tool I personally favour above all else is the pastel itself; colours mixed by laying one over another look more lively than blends. There are different ways of mixing by overlaying. If you apply the pastel lightly, one colour will

Ruggles Farm House by Rosalie Nadeau

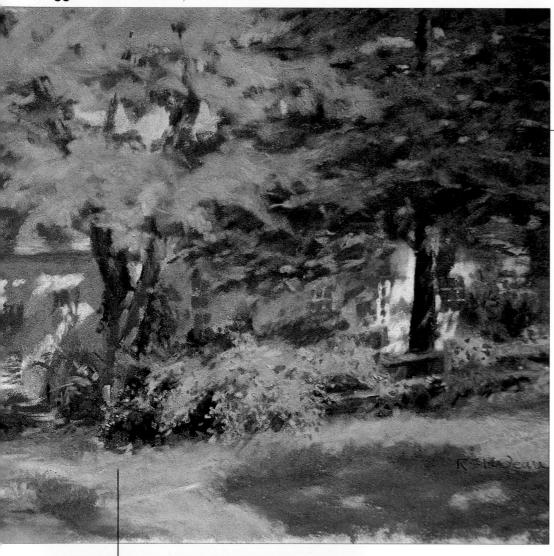

dark olive green has been overlaid with a lighter tint of the same colour, applied with very little pressure so that the light colour does not look too solid. This is an important lesson in colour mixing with pastel – vary the pressure you apply to control the density of your colours. Heavy pressure on your second layer will obliterate what is under it rather than blending with it.

Layering colours This detail clearly illustrates the artist's method of layering colours, and also shows how successfully light, bright colours can be laid over dark ones (the pink flowers have been laid over the shadow

on the left). The only drawback of this is that the dark pastel may bleed through the light covering if you are too generous with the fixative. show through another. A picture can be built up from linear strokes of different colours laid both side by side and on top of one another, or you can use the side of the pastel stick to drag successive layers of colour. In Rosalie Nadeau's painting, she has used the pastel thickly, pushing the colours together. This has enabled her to achieve more density of colour than conventional blending, which removes a good deal of pigment from the paper. In the foliage of the central tree, the green was applied over the yellow, with two tints in a variety of marks. The darker tree to the right has overlays of lighter olive on a deep olive. The paper is almost completely covered, but the density and opacity of the pigment was no obstacle to achieving subtlety.

The sunlit foliage gains vibrancy from the fact that the hues are distinct but the tones are close, that is, the artist has used colours that are not substantially lighter or darker than each other. The darker tree is made of greens of the same family so that the effect is very subtle.

Soft pastel overlays

Much of your colour mixing will be done by laying colours on top of one another. Generally, the first layers will be relatively lightly applied, with thicker pastel used when you are close to completion.

Solid pastel overlaid with linear strokes.

Here the top layer has been applied with the side of the pastel.

Using the side of the pastel quite lightly for both layers, allows the white paper to show through.

Graduating colour can be useful for describing objects in the light. Here linear strokes were applied.

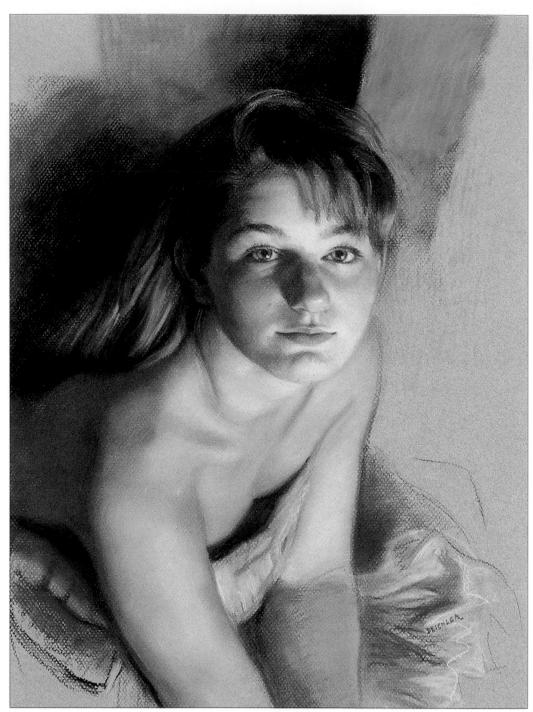

Nikki DEBORAH DEICHLER

We can do a bit of detective work on the technique used by Deborah Deichler for her portrait study. At the bottom of the picture, where the drawing stage is still visible, and the pastel only lightly applied, the regular indentation of the paper texture can be seen, but as we follow the arms upwards these disappear even though the colour is still quite lightly applied. This means that the artist must have used an implement to blend the colour and push it into the grain of the paper. In fact she used

her fingers, the blending "tool" preferred by many artists in spite of the necessity of much hand washing. The colour has been kept clean, and the blending used carefully to model the form by subtle gradations of light.

Oil pastel Mixing oil pastel is another process altogether. The fact that it is greasy means that it builds up quickly on the paper, making it difficult to achieve subtle mixes. However, oil pastel can be dissolved with white spirit or turpentine so that it behaves much like paint. If you wipe over a light scribbling of pastel with spirit, using either a brush or a rag, you can spread the colour very thinly and build up subsequent layers of colour on top. It is best to use oil-painting paper, primed paper or board for this method; pastel paper may eventually become brittle and fall apart. A brush dipped in spirit can also be used to blend colours into one another, or you could even dip your pastel in it. If your colour is building up too heavily you can wipe if off with more spirit. Or you can scrape into the pastel with a blade; this produces interesting textures which can be controlled with practice. You can burn your fingers, literally, when blending dry oil pastel, so if you do use your fingers, rub gently.

Oil blending techniques

Oil pastel is a very rich medium, and can seem very cloying. It is a good idea to try out different means of mixing your colours so that when you start painting an actual subject you are prepared

for the way the medium behaves. I always have some turpentine, plenty of rags and a knife with me when I use oil pastel.

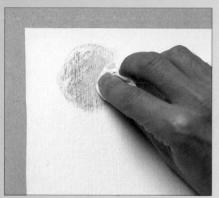

Rubbing with a turps-soaked rag makes very delicate washes of your oil pastel scribbling.

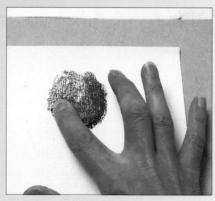

You would rub with a finger if you wanted to blend more thickly applied colours together.

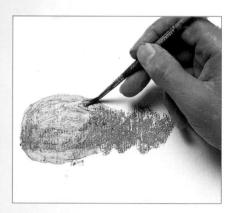

A brush dipped in turps enables you to spread out colour from a thick application to a subtle wash.

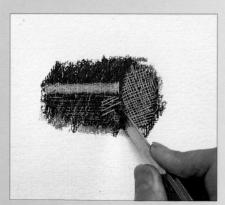

Scraping with a knife is a good way of introducing sharp notes and edges into a densely worked oil pastel.

Dip a cotton wool bud in turpentine and gently rub the area you want to blend.

Use an eraser to rub over the area to be blended

identifying colours

It's very difficult to decide which colour to use from my collection of pastels – any advice?

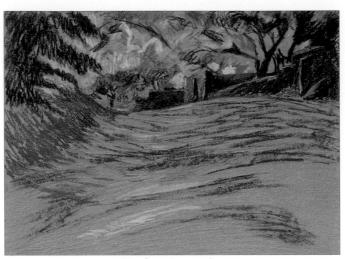

Student's version

an col

Keep colour
swatches of each
hue in your palette.
Holding these up
against the object
you are painting
will make it easier
to see which colour
matches best.

the PROBLEM

Choosing the pastel colour that most closely matches something in your subject can often seem difficult. In a landscape, for example, the sheer number of greens is overwhelming. But even with a still life the choice can be difficult, especially where colours are reflected in the surface of another colour, or where there are expanses of background that don't seem to fit into any colour category. The student has tackled the problem bravely in the picture above, but the colours are rather bitty and don't help in holding the picture together. The background, particularly, is confused.

the solution

There are three related problems to deal with here. The first is correctly matching a pastel to the colour you are looking at – and remember you may not find an exact match; the second is keeping your colours in a logical order so that you can find them quickly; and the third is to make sure that you do not lose sight of an overall colour composition when you make your choices.

Jann T. Bass has dealt with a large area of open foreground by using three main colours: two pinks and a grey. Expanses of ground can be difficult as there are so many nuances and shades it's hard to identify colour. The

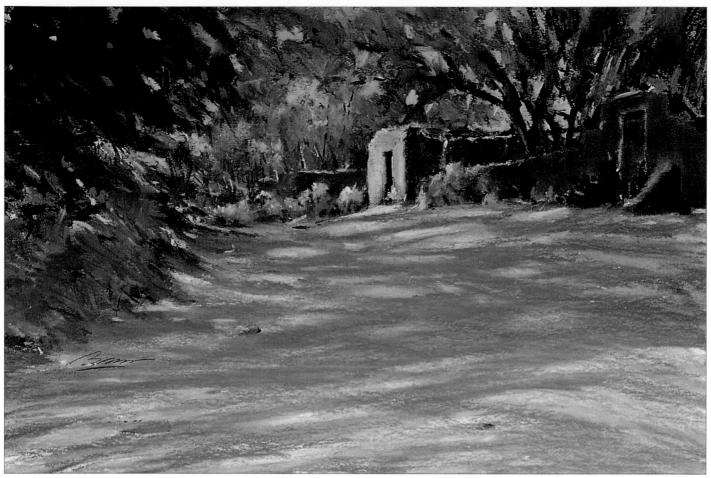

Otono by Jann T. Bass

artist has solved this by looking at the area as a whole and not getting involved with too much detail. He has looked for light and shade but not overstated the contrast between them which would have distracted from the interesting buildings in the background.

Colour matching While you are still familiarizing yourself with the pastel medium it is a good practice to keep some strips of paper about 5cm (2 inches) wide on which to make colour swatches. Divide each strip into bands so that each band can be coloured with all the different tints for each hue. To be prepared for the occasions when you use different coloured papers, also keep strips in a variety of coloured papers that you are likely to use. When you apply the colour make it solid at the top and lighten the strokes towards the bottom so you have a graduated colour swatch. If you hold out your colour swatches against the object or area you are trying to identify you should be able to find something close to it.

Colour contrast Another way of discovering the exact nature of a colour is to hold up a contrasting colour swatch. If you are trying to identify a particular green in a mass of greens, hold up a variety of red swatches; this will heighten your perception of the green. All the colour complementaries will do the same; for example, if you are looking at an indeterminate neutral brown or grey try assessing it against a strong primary, which will help you see its colour bias.

swatches made from the same

Using colour swatches

artist has used colour

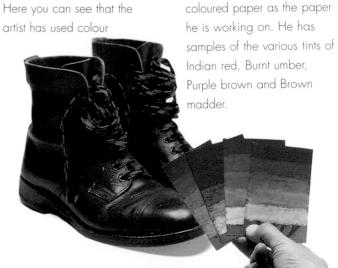

light colours

I like the delicate
effect I see in some
pastel paintings.
How do I
achieve it?

Student's version

Work lightly; don't rub the pastel too much. Stand back from your picture often, so that you can judge the overall effect.

the PROBLEM

In doing this picture, the student has discovered that there is more to achieving an overall delicacy of effect than simply using pale pastel tints. One reason for her failure is that she has applied the pastel too solidly, which makes the colour too strong and opaque simply because there is so much pigment on the paper. Also, the number of colours used produces a confused and overloaded surface, and there is no overall relationship of colours. In the student's picture the contrast between areas in sunlight and shadow is too harsh, giving no sense that the ground is the same substance whether in sun or shade.

the solution

It is tempting to work intently on a picture, standing close, and only moving back to assess it when you think it is almost complete. Stand back from it frequently, especially when you are working in colours of close tone and hue. It is vital to see your picture as a whole, judging whether the separate parts make a unified effect instead of fighting one another. In areas where shadows fall across the ground, look for colours that the light and shade have in common. Work lightly, keeping your colour broken so that one

shows through another, and allow the marks to show – over-rubbing and blending produces muddy and indeterminate surfaces. In *Country Road* there is a simple colour harmony, a meeting of yellow greens with pale violets. The same colour is used for the shadows on the road and between the branches, where it suggests sky, so that there is a link between the top and bottom of the picture. There is no overworking; economy of means allows the colour to work without confusion. To add those necessary touches of solidity and opacity, browns have been used in the hedge and on the walls of the cabin. Out of the greens and violets small sharp notes of pink and red animate the surface without overwhelming or confusing the colour balance.

Dark and light Even when you are aiming for a close-toned and relatively pale picture it is useful to decide what your darkest colours are going to be, how dark they are, and where you will put them. Similarly, decide on the tone of your lightest colour and consider where you will place it. Once you have decided on the two extremes of your tone and colour range you will find it much easier to make subsequent colour decisions.

Country Road by Irene Christiana Butcher

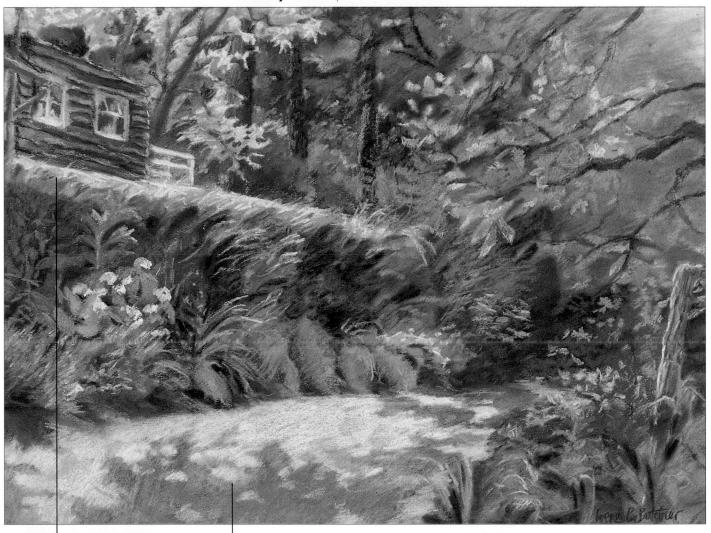

Main colour The artist has kept the light part of the road very pale, with the main colour in the dappled shadow.

Structure Lemon yellow, complementary to the violet, is a strong structural element. The strip on the top of the

hedge pushes the dark cabin into the background, while the bright sunlight illuminates the leaves in the tree.

avoiding muddy colour

I try to get subtle colour by mixing, but always seem to end up with mud.

What should I do?

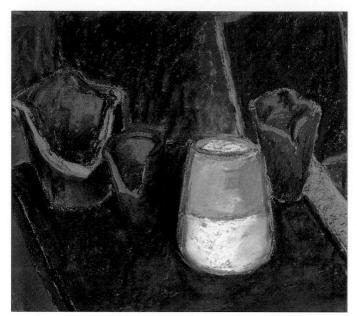

Student's version

Avoid too much blending and rubbing of colours, as this can deaden the colours and spoil the surface.

the PROBLEM

I have heard this lament so often, and it is one of the major problems encountered by inexperienced pastel painters. As happens frequently, the student has overdone the blending so that the paper has become clogged and the pastel seriously overworked. She has also used a lot of black and white to exaggerate the lights and darks, which has produced a coarsening of the image. While there is nothing wrong with black, it can have a deadening effect if not used with sensitivity. Another difficulty that arises when dealing with subdued colours is identifying their precise nature, and uncertainty over what kind of browns and neutrals she was dealing with has led to characterless rather than subtle colours.

the solution

To make subtle browns and greys it is not necessary to put a large quantity of pastel on your paper. Rosalind Cuthbert has kept her pastel to a minimum yet still produced an effectively subtle image in her "Pots from Chateau des Fours". None of the colours are full hued, and several of them are the so-called earth colours, the ochres, browns and red-browns made from common ores and oxides which are the oldest colours known to artists. The only black in the picture is charcoal which is a much weaker black and black pastel. It was used to lightly draw the composition first and for darkening some of the shadows of the table.

Papers and grounds The painting was done on a midgrey ground – a wash of dilute Chinese ink – which gave her an advantage at the start. She has not needed to overblend her colours to give them weight. None of the blending was achieved by rubbing but by laying one colour lightly over another. The paper chosen was a smooth "waterleaf" watercolour paper, which is fairly soft, and thus precluded any heavy rubbing or erasing.

Choosing the right colour for your paper is very important when the colour scheme is subtle. The grey of the paper blends with a pastel grey, raw sienna and a tiny hint of mars violet, with touches of charcoal providing a further grey. Notice that where the grey paper comes through the warm pale colours of broken pots it looks quite different.

Pots from Chateau des Fours by Rosalind Cuthbert

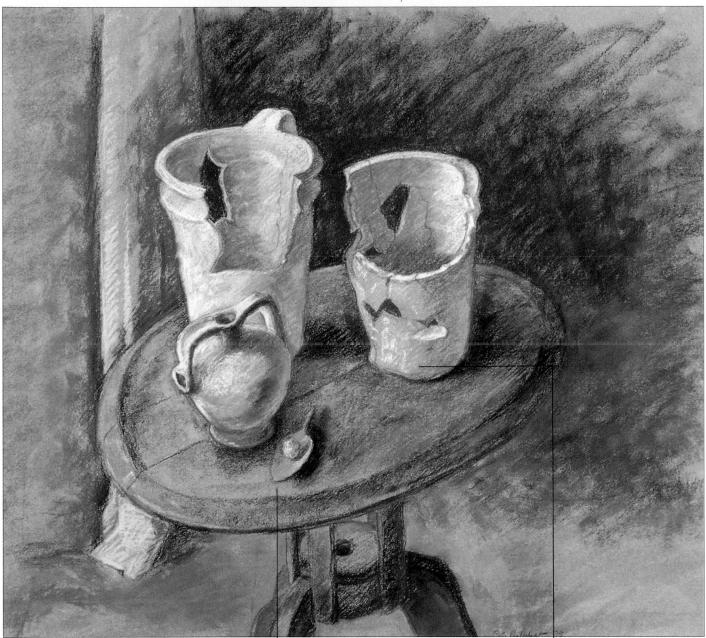

Using charcoal Using grey pastel on grey paper with the outline in charcoal is a very economical way of giving form to the spoon. Note how well the shadow lifts the spoon off the table top. This detail shows very clearly that it is not necessary to labour on smudging and smoothing to make subtly lit forms effective.

Hatching Mark making is a crucial element in this picture. The hatching not only describes the volume of the pot, but also gives a gentle shimmer to the surface because of its broken quality. Even here the artist has used a grey pastel, more blue than the paper.

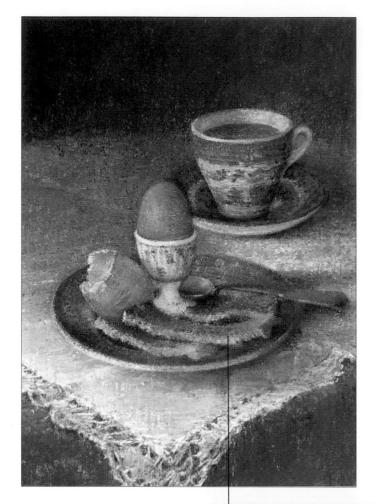

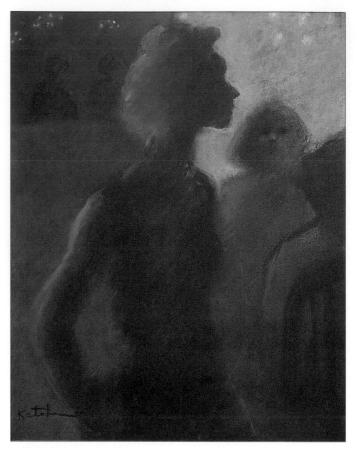

In the Shadows CAROLE KATCHEN Limiting colour and using

strong tonal contrasts has enabled the artist to avoid any muddiness. A strong

design sense integrates colour, tone and placing. See how the light and dark alternates between the head and its background.

Breakfast on Wedgwood CHARMIAN EDGERTON

Putting shadows into a painting, especially if they are cast across surfaces with not immediately identifiable colour, can result in muddy colours. Charmian Edgerton has avoided deadening shadows by heightening the colour. She has brought out the purples, blues and reds in opposition to the creamy colour of the tablecloth.

Colour The artist has painted three fingers of richly coloured toast, in which the colour has been applied in layers, some

of which are only dots and broken texture. Notice how there is red and even a sprinkling of blue dots, the

rough surface admirably suggesting the crumbly quality.

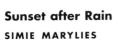

The mauve paper is roughly the mid-tone between the yellow, pale turquoise and the very dark blue used for the trees and shadows in the foreground. Even though this is a twilight picture the failing light has been expressed in rich colour.

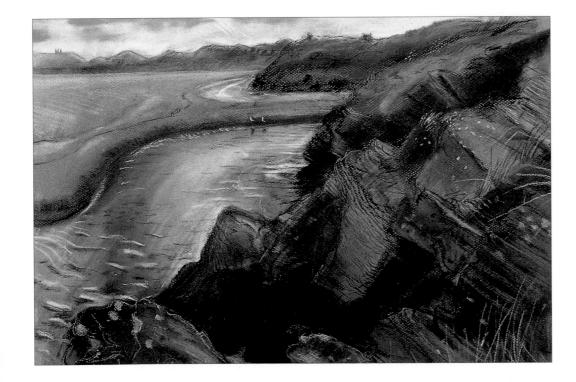

River and Rocks JANE STANTON

This pastel was done on an olive green paper which is visible over much of the surface. The light water reads as the strongest colour simply because it is the brightest area. Elsewhere, although there is some red in the rocks, the colours are muted, but the qualities of light have been carefully observed, preventing them from appearing in any way dull. The composition is enlivened further with energetic line and strong tonal contrast in crucial places.

colour and TONE

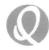

My painting seems monotonous, how can I get more contrast?

Limit the number of colours in your painting and utilize the wide-ranging tonal variations of those you do use.

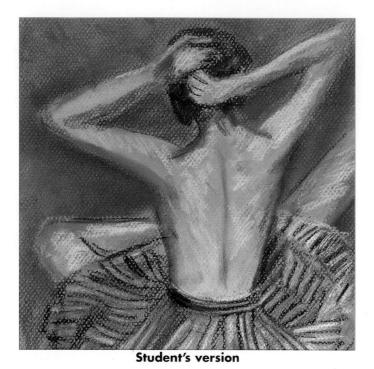

the PROBLEM

The student's picture has an even similarity of emphasis throughout, with no contrast, either of colour or of tone. A few really dark tones would have improved it, but what seems to have happened is that uncertainty as to what the picture is about has kept the student from making it work in pictorial terms. The figure drawing is not bad, and in individual areas the colour is handled well enough, but as the student has realized, the painting fails to come alive as a picture. Perhaps she was nervous of overstatement, of exaggeration, but by choosing a subject, the artist is already giving something importance and singling it out for attention, so why not make the most of it? Picture-making is what we are trying to do, and whether the medium is pastel, watercolour, oils or egg tempera it is vital to consider the pictorial concerns.

the solution

Designing a painting involves more than working out the drawing and colouring it in. The colour should be seen as integral to the whole picture right from the start. It is hard

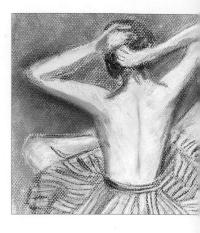

Monochrome study The black and white reproduction reveals there is very little contrast of either colour or tone.

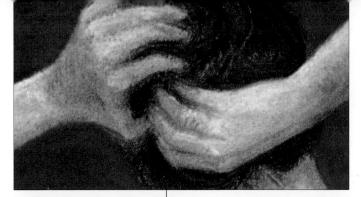

Illuminating an object Illuminating an object, giving us lighter and darker facets, enables us to grasp its threedimensionality. See how the

shadow on the back of the

left hand not only tells us that the hand is bending, but that the head, of which we can see very little, is an object with depth.

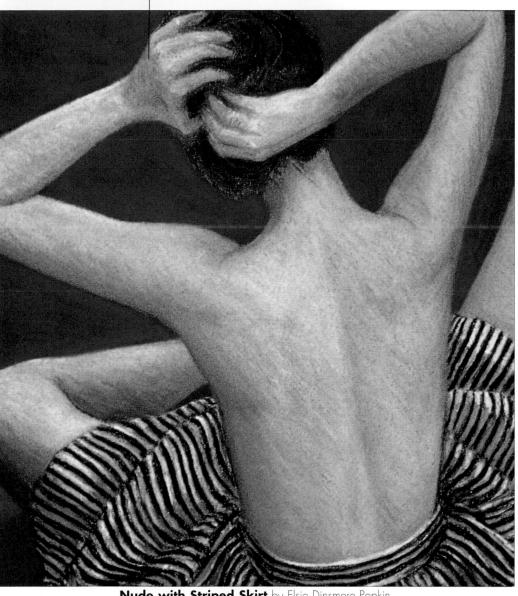

Monochrome study The black and white reproduction loses the drama of the red, but allows the tonal pattern to be seen clearly. Notice that there is a tonal modification of even the red, at the bottom left.

Nude with Striped Skirt by Elsie Dinsmore Popkin

to imagine Nude with Striped Skirt without its strong colour. As you can see, it loses its striking contrast when reproduced in black and white. The red becomes a midgrey, close in tone to the shadowy effect of the figure and the shadow on the white of the skirt. However, if you compare this with the black and white reproduction of the student's picture, you can see that it still looks considerably more exciting because of its tonal contrasts and strong pattern.

Limited palette Even though Nude with Striped Skirt strikes us as colourful, the colour is, in fact, quite limited. The student has used a wider range of colours but achieved far less "value". One way to achieve the impact that comes from contrast is to limit your colour; if you use too many colours there is a danger of monotony and greyness. Many artists do, of course, use lots of colours and make them succeed together, but this is a complex problem of orchestration (see Colour Unity on page 48).

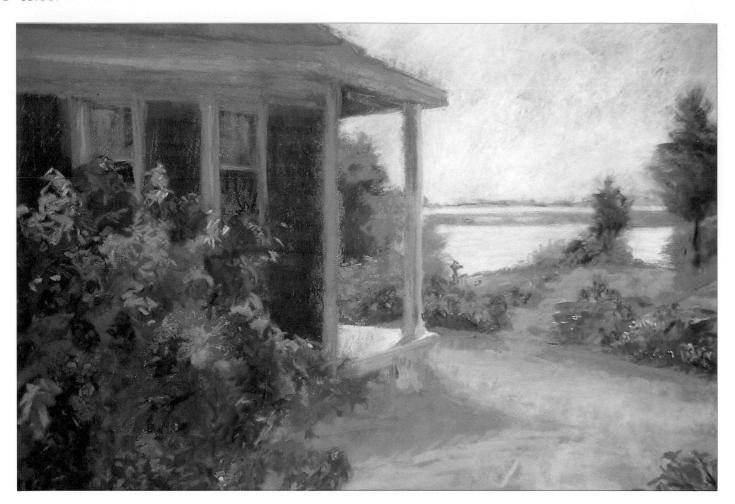

Tone and colour When we talk about tone we mean the degree of lightness or darkness of any colour, regardless of the kind of colour it is. Contrast can be achieved purely through the use of tone. The stripes in the nude's skirt contrast with each other, the pale hands are in tonal contrast with the hair. A mid-tone is used to give shade to the back of the left hand, making a more subtle contrast to the light fingers. These variations are caused by the way surfaces absorb or reflect light – light and shade affect objects whatever their colour.

It is a little artificial to separate tone from colour, because we see the world in colour, but it is important to recognize the tonal values of colours.

Lightening and darkening So you must consider how to darken or lighten any given colour, and this can become complicated. If you take a cadmium red and add black to darken it you will get a rich chocolate brown. A deep blue will also darken red, but it will turn purply if it is a warm blue such as ultramarine, and brownish if it is a cool cerulean or Prussian blue. White added to red will turn it pink. So everything that you use to modify a colour does more than just lighten or darken. In most cases, when you

Cottage by the Coast ROSALIE NADEAU

The lawn on the right is positively hot compared with the yellow-orange under the green, and the distant green bar beyond the water is

correspondingly cool.
Interestingly the further strip of land is yellowish, but this does not break the rule as the brown makes it cooler than the yellow-orange in the foreground.

mix two colours together you will get a reduction in the intensity, an exception being the addition of white to very deep colours like Prussian blue or crimson, which heightens the hue.

Warm and cool colours Another fact you need to know about colours is that some are "warm" and others "cool", even when the colours belong to the same "family", say blues or reds. Warm colours tend towards red and yellow, cool ones to blue. Warm colours tend to advance towards the viewer, while cool colours recede, so if the warm and cool relationship is misunderstood then you get a haphazard and contradictory effect. If you used warm colours in the background of a landscape and warm in the foreground, for example, you would have no sense of space and recession.

Tranquil Corner SANDRA BURSHELL

In this hot red picture, the shadow area under the table

is cool in relation to the other colours, so that it tends to "sit back" in the picture.

Tone and colour

The most immediate way to make a colour darker or lighter is to add black or white. This method makes the degree of darkness or lightness easy to control but the effect can be rather crude. A strong blue, as shown, will take a black well but a pale green is overpowered by it.

Lightening and darkening

If, when you are trying to darken a colour, you find that black is too harsh, try a blue instead. In this chart we can see the difference between modifying a cadmium red with black. white, ultramarine blue and cerulean blue. The cerulean, which is very close in tone to the red. has produced a good grey. The stronger ultramarine is darker and harder but not as overwhelming as the black. The white makes a satisfactory pink.

Cadmium red + black

Cadmium red + white

Cadmium red + ultramarine

Cadmium red + cerulean blue

Warm and cool colours

The difference between the warm and cool variants of colours may not seem very significant but when you see them together the different qualities are quite marked. Cool colours tend to suggest space, while warm colours, relatively speaking, are the colours of surfaces.

Warm Cool yellow yellow

Warm Cool red red

Warm Cool blue blue

Warm Cool green green

colour unity

Have I used too many colours?

My picture doesn't If you are using lots seem to hang of colours, look together properly. for unifying factors to hold the picture together.

Student's version

the PROBLEM

There is something very seductive about a lot of bright colours, and a box of pastels does tempt you to use as many as possible. But a highly coloured painting must be organized in some way. It is necessary to look for unifying factors, elements that will hold the picture together, and the student has failed to do this. She has mixed warm and cool colours randomly so that it is difficult to interpret the position of things in space; warm colours tend to come towards the viewer and cool ones to recede, a range of dynamics that can disrupt the strongest of drawings. She has also used every colour in more or less even quantities so that no one hue predominates, destroying the unity of the picture.

the solution

My picture Evening Light, Fiesole contains many colours: red, orange, yellow, green, blue, indigo and violet – all the colours of the rainbow, in fact. I began by choosing a pale sand coloured paper. However, after working on it for some while I found the relationship between my colours and the paper rather drab so I left it alone for a week. When I came back to it I felt that the whole picture needed something drastic, something to change the colour balance so that I would have to work hard to regain the image. I took some violet acrylic and diluted it with water in a little container, then using a diffuser I blew a spray of violet over the entire surface. This immediately made the overall colour much richer. The acrylic helps to fix the first layer of pastel so I was ready, once it was dry, to work on. I concentrated on the pinks, reds and yellows, where the light was warming the trees and other elements in the landscape. The underlying violets and the orange, made by the violet acrylic on the paper, act as a base colour. The effect of the light gives a logic to the colour organization. There is a strong link between two isolated areas of strong colour, the tiles at the bottom relate to the distant buildings, helping the overall sense of scale. Integration is the key to successful handling of colour. Equal amounts of colour tend towards disharmony, so to gain harmony an underlying colour scheme, violet and yellow in this case, is set off against smaller areas of other colours.

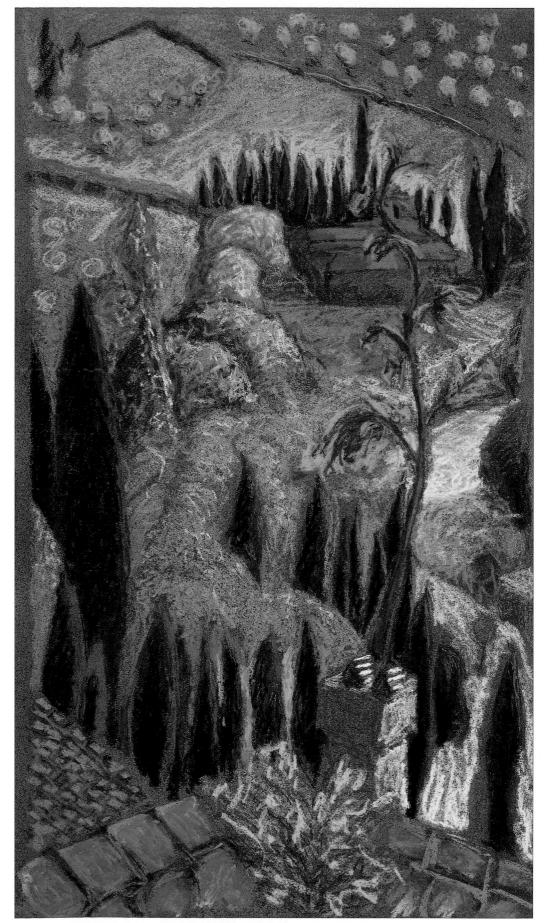

Evening Light, Fiesole by David Cuthbert

Colour Unity

Making a subtle change over the whole picture area with pastel would involve laying on a complete new layer. Instead, you can use a diffuser to spray paint over the pastel.

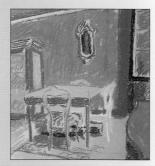

At this stage in the work the pastel is fairly close toned.

To deepen the colour dilute blue acrylic was sprayed through a diffuser.

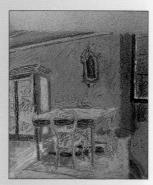

The blue has not only made the overall colour richer but also shifted the tonal balance slightly.

landscape GREENS

The greens in my landscape all look the same. Should I buy more pastel colours?

Student's version

A

Buying more
colours will
certainly help. Try
using different
pastel marks to
give definition to
the varied surfaces
in your picture.

the PROBLEM

In the well-watered parts of the globe there is a time in the year when the lush greens of the trees and fields are almost overwhelming; looking across the landscape there seems to be nothing but green. As a teenager attempting my first on-the-spot landscape I could not believe it was possible to mix the incredible range of greens I saw, and the student has had the same problem. But she has made one fundamental mistake in tackling it – assuming that choosing a pale green paper would give her a head-start. In fact it has given the pastel colour an impossible task, because there is not enough contrast to make the greens sparkle. Another fault is in the handling of the dark greens, which shift uncertainly between khakis and grey-greens, failing to achieve the rich depth of shadow that would make the highlights "sing".

the solution

You may need to invest in some more colours, and a huge variety of greens is available; if you buy colours from different manufacturers' ranges you could probably have as many as sixty. But this will not guarantee a successful picture. In *Forest Scene* James Crittenden has used a fairly limited range of no more than a dozen greens, some lilacgreys and touches of brown and black. The drama of the

picture lies in the surprising darkness of the trees and the sharply lit grass in the centre. It is the simplicity of composition that makes it work.

He has also chosen the paper colour wisely. Working on a green paper, as the student has done, might be fine for an autumn picture, as it would provide a good contrast for the warm colours, but in this case it has made it impossible to assess the applied greens.

James Crittenden used a mid-toned sand-coloured paper, which has enabled him to judge the dark and light colours as well as giving areas such as the immediate foreground a nice sparkle, as the paper colour shows between the pastel marks.

Contre jour This French term simply means against the light, and is an effect often used by artists. It can be tricky, as looking into bright light will cause you to see a variety of strong after-images which may give you problems when selecting the right colours. However, there are advantages, especially when dealing with a monotonously green landscape as objects such as trees appear in dark semisilhouette. Notice how dark Crittenden's trees are against the sky, and the striking difference in tone between the bright sunlight on the middleground and the shade in the foreground.

Pale colours White and very pale yellow has been applied densely to give crispness to the dark shapes of the leaves. The light has "burned through" so that not all the connections between twig and leaf are visible.

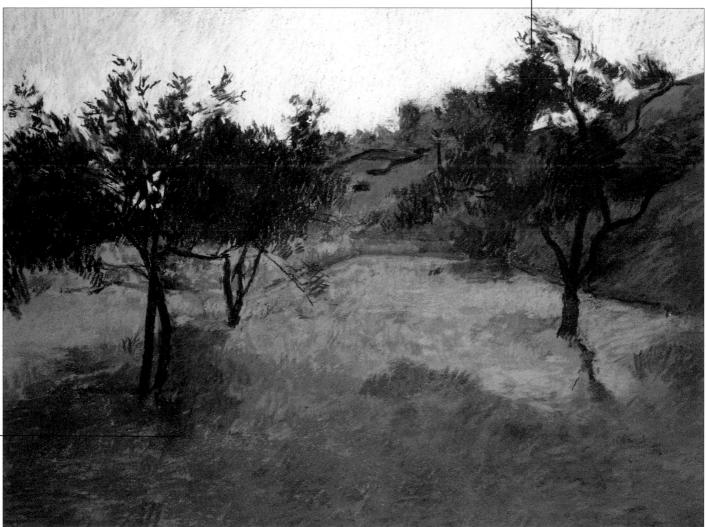

Forest Scene by James Crittenden

Colours This detail shows the variety of colours and marks used for this area; hatching strokes in various greens, blue-greens and violetgreys, with the paper showing through to provide a further colour.

British Camp Reservoir, Malvern DAVID PRENTICE

As in James Crittenden's painting on the previous page, the range of greens is not large, but Prentice has enlivened the composition by contrasting the surface qualities of the main masses. Notice how the large slope in the centre of the picture is broadly painted, light pastel dragged over dark. The same colours can be seen in the wooded hill beyond, but the mark making is all-important in describing the difference in surface. The darkest trees, those in the right-hand corner of the picture, are very vigorously made, with the flat surface of the reservoir smooth in comparison.

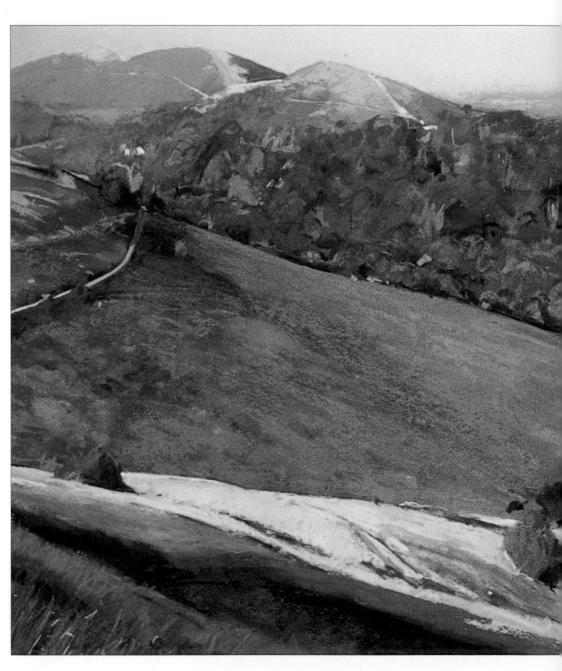

Distant greens A common mistake is to make distant greens too vivid, sacrificing both variety and the sense of space. When we look across a landscape we are looking through air containing tiny particles of dust and moisture, which filters out much of the colour, softening the contrasts and giving greens a blue tinge. This effect, called atmospheric perspective, can be seen in David Prentice's *British Camp Reservoir, Malvern*. Although the predomi-

nant colour is green, it gradually thins, and becomes pale blue as it approaches the horizon.

Low contrasts Not all landscapes provide strong light, dark shadows or deep space; often a quieter, less obviously dramatic scene will present itself as a subject.

In James Crittenden's painting of an orchard, there is little strong contrast, but a rich variety of colour, creating

Orange Grove in the **Evening**

JAMES CRITTENDEN

In this painting, life and movement are conveyed by the multi-directional hatching and squiggled strokes on the trees. Sparkling areas are the result of letting the pastel paper show through strokes of colour.

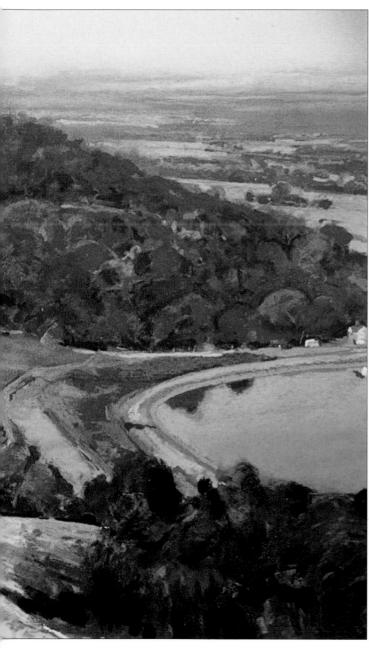

a convincing impression of light-filled, leafy space. Again, the pastel marks play a vital role in the composition, with multi-directional hatching and squiggled strokes on the trees describing the surfaces and giving a feeling of life and movement. As in his previous painting, he has worked on sand-coloured paper, which shows through the pastel in places, and has avoided overworking the colour so that it has a clean freshness.

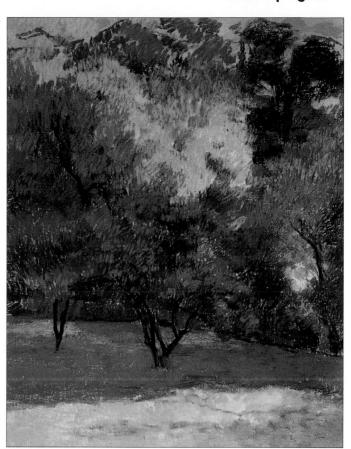

A palette of greens

Artists who have favourite subjects build up pastel collections to reflect this. If you are into landscapes you will want to add some extra greens to the basic palette recommended on page 14. Here we suggest some useful greens to start with.

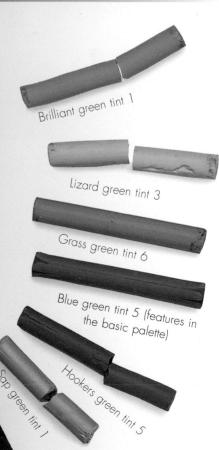

skin TONES

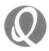

How can I make
skin colour look
alive without losing
the subtle colours?

the PROBLEM

Teachers at art classes are often asked how to mix "skin colour", but of course there is no such thing – no one would ask how to mix "sea colour" or "flower colour". Skin varies in colour even on one face or limb, and this is before we start thinking about differences between one person and another. The student has tried much too hard at subtlety, so that the colour is too even to be naturalistic.

Student's version

She has also smoothed it out so thoroughly by rubbing and blending that all definition has been lost, and the face looks as if it has been heavily made up with foundation cream and powder. Some parts of a person's face, such as the cheeks, will look soft, but where the bone is near the surface there will be harder edges, and on the nose, lips and eyes there are likely to be distinct highlights.

the solution

In *Alberta*, Doug Dawson has used his pastel colours thickly, but without overworking, smudging or smoothing. He has produced a very convincing rendering of a particular skin, while using a wide variety of colours on the face alone – notice the blue-greys and green-browns

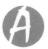

Apply an
undercolour with a
brush. The
brushmarks create
a textured
foundation which
will break up your
pastel strokes and
keep the surface
light and lively.

Alberta by Doug Dawson

Colour highlights The little points of blue are important in enlivening the oranges, pinks and ochres. Under the jaw near the mouth and on the chin small flecks of blue break up the warmth, giving a shimmer to the surface.

Underpainting Here we can see the effect of pastel on top of underpainting. The brushmarks act as a textured ground which breaks up the flow of the pastel stroke.

among the pinks and ochres on the lit side of the face. Because these colours have been kept close in tone, they mix optically, to read as the basic skin colour. A juxtaposition of dark and light colours would create a jumpy impression, and confuse the forms. Places where the face disappears into shadow on the dark side have been allowed to dissolve.

Underpainting Artists of the Renaissance period used to lay a grey-green undercolour for the skin, over which they painted the warm skin colours in thin layers. Doug Dawson has used a related technique in his pastel portrait,

applying size (undercolour) with a brush before putting on the pastel. This has created an underlying texture, which you can see clearly towards the bottom right corner where the strap of the dress crosses the arm. There are some broken lines, which are caused by the pastel strokes being broken by brushmarks. Above the dress strap there are more lines visible, this time in other directions. A textured underpainting is a good method of preserving a sense of light and liveliness on the surface.

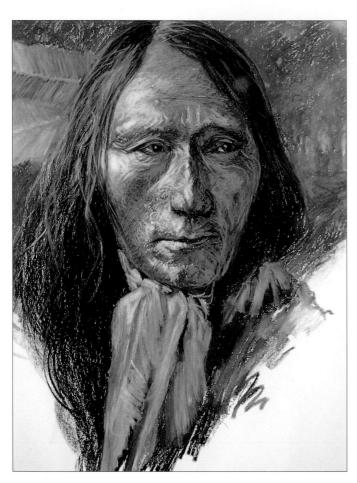

Kills Enemy Cool

Some artists like to build up a rich surface with a network of overlaid colours, completely obliterating the paper below, as in *Kills Enemy Cool*, where

the skin colour is derived largely from the very cold light illuminating it. Not only is there colour on colour, but also linear work on top of relatively close-toned areas,

Lighting

When you want to explore the qualities of skin colour, set up your model in a good light, but one that is not too harsh. Alberta (see page 55) is lit from above and to the left, with a light that casts quite deep shadow, but does not cause the light areas to look "burned out" or bleached. Even the highlights on the temple, cheek, nose and shoulder are relatively

soft. The sharpest white is on the necklace. With lighting like this the richest skin colour will be just at the edges between the lightest skin and the shadow.

In this panel we show a model lit from different angles to demonstrate the different effects to be achieved with highlights and shadows.

The Artist's Father DAVID CUTHBERT

A quick study of my father, made as a "warm-up", shows the possibility of getting a record without too much fuss. The paper, a sort of milky coffee-colour, helped me to keep my colour to an absolute minimum, just a pinky-beige for most of the skin and Indian red for the warmer hues, plus black and white.

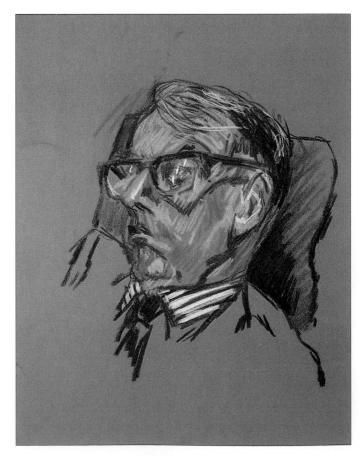

Softly lit from above creates soft highlights on nose, shoulders and breastbone.

Soft lighting from the side creates an air of mystery and casts interesting shadows.

Strong lighting from above reduces shadow.

Strong lighting from the side casts hard shadows and strong highlights.

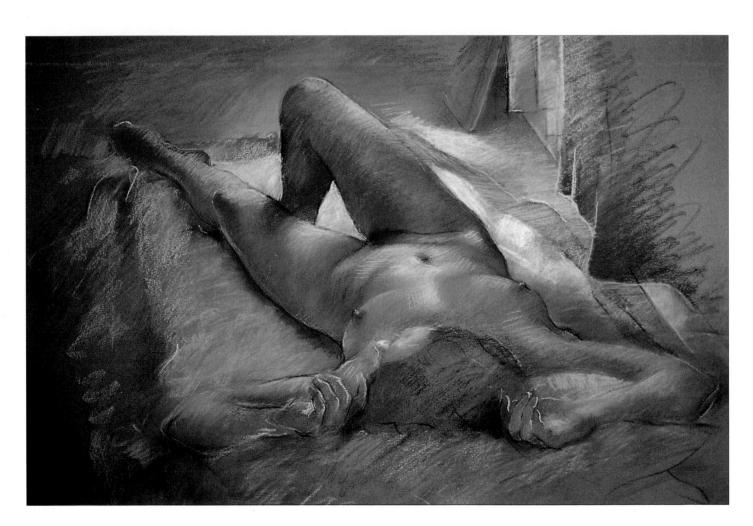

Reclining Nude ROBERT MAXWELL WOOD

Robert Maxwell Wood's sensitive picture of soft light falling across a body was achieved with several kinds of pastel. The initial drawing was made with charcoal pencil, then a mixture of soft pastels and pastel pencils for the colour. The paper was a slightly warm stone-grey which tends to look greenish against the warmer skin colours. The final effect of light and delineations of the fingers were done with white conté crayon, which is firmer than the soft pastel.

extending your PALETTE

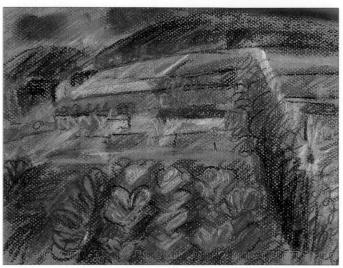

Student's version

Sometimes I can
get the exact
colour, but other
times I can't even
achieve it by
mixing. Any
advice?

You cannot always
imitate a colour
exactly, but you
can use a similar
colour or look for
one that is
equivalent in effect.

the PROBLEM

There are colours that are impossible to mix; either you have the right colour or you don't. Some of the reds, violets, magentas and pinks you see in flowers – or in chemically dyed textiles – can't be made by mixing either reds and blues, or crimson and whites, as this sacrifices the brilliance of colour and hence its particular character. An additional problem is that of achieving the full variety of just one colour which you will often see in your subject. A field of cabbages, for example, is all the same local (actual) colour, but there will be a huge range of subtle variations. In the student's sketch there is a lack of co-ordination which suggests a conflict between the attempt to attain accurate colour and the demands of a satisfying colour composition.

the solution

With any painting medium, mixing will tend to reduce the intensity of the colour, so when you want a particularly sharp note the best way is to find the exact colour, or the one that most closely approximates to it. If you are working with a small palette of colours, you may need to consider enlarging it, collecting a good range of each colour. Daler-Rowney produce five violets, eight reds and

Red Cabbages by Patrick Cullen

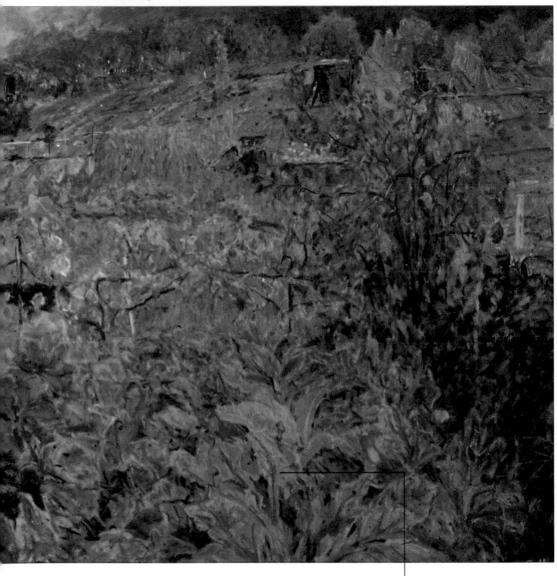

eleven greens, not counting the tints, all with their own distinct note, and some manufacturers' ranges are even more varied.

Patrick Cullen has chosen a subject that demands blues, blue-greens, pinks and violets, hues which he has achieved with the minimum of mixing. For the veins in the cabbages in the immediate foreground, for example, he has chosen a sharp violet from his extensive collection of pastel colours.

Complementary contrast Remember that colours are affected by those that surround them or are placed next to them. A colour can be heightened by juxtaposition with its

Leaf veins The violet of the veins blends in with the blueish leaf colour. It would have appeared more vivid if paired with its complementary – yellow.

Colour swatches These swatches show how colours are affected by those that surround them. The centre in each square is the same violet. The surrounding colours are, lilac-blue, blue-lilac, blue, blue-green, green-blue, green, yellow-green, yellow.

Lilac-blue

Blue-lilac

Blue

Blue-green

Green-blue

Green

Yellow-green

Yellow

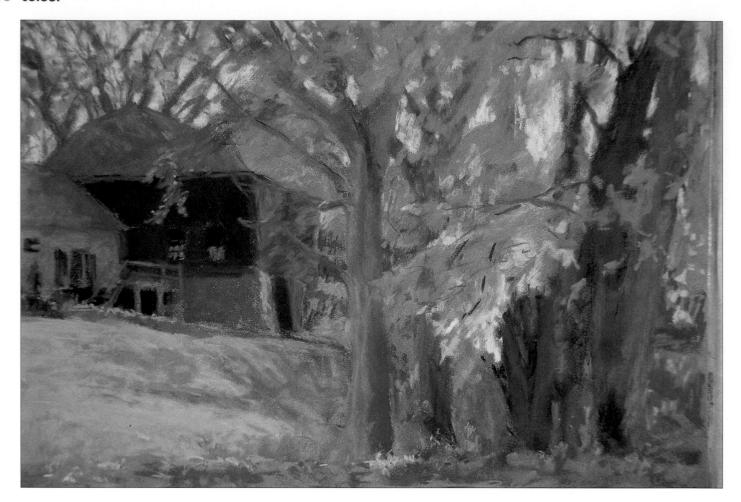

Fall Fire ROSALIE NADEAU

This exciting pastel painting makes use of two main colour combinations, both of them complementaries - red-green

and yellow-violet. Note how the red is contained within the crisp shape of the house, while the green is relatively soft and formless, so there is another contrast in the quality

of shape. The violets are less obvious, but they are there, mixed with browns and oranges in the tree trunks, and with greys and blues in the roof and small building.

complementary, so if you find that your violet is not as sharp as you would like, try working some lemon yellow against it; this will "force" it towards a sharper red. You may find it useful to collect colour swatches in your sketchbook, repeating examples of each colour with variations of the complementary against it. For instance, try a row of cadmium orange swatches with a different blue against each one to see how differently the oranges appear.

Colour equivalents Even if you have amassed a large range of pastels you may still find that some colours elude you, so you will have to find an equivalent for the colour you can't match. There is often misunderstanding about this idea. A colour equivalent is not necessarily the nearest in the spectrum to the colour you are seeking; it is the one that is nearest to it in effect. If you are trying to find a vivid

pink, the nearest colour in your box could be a crimson or a violet, but both may be relatively dull, so a better choice could be an orangey red simply because it is the equivalent in vividness. Compared to Patrick Cullen's Red Cabbages, the student's picture is dull, and the colour range unimaginative. This is not simply because his palette was too restricted; it is also because he has not really looked for the colours that were there. Relying on a huge range of greens is not really extending your use of colour. Don't assume that grass, trees and cabbages are green; if you look carefully you will see other colours as well. Red Cabbages reads as a green landscape, but green is not the predominant colour. The artist has got the most out of his greens by combining them with yellows, reds, pinks, oranges and browns.

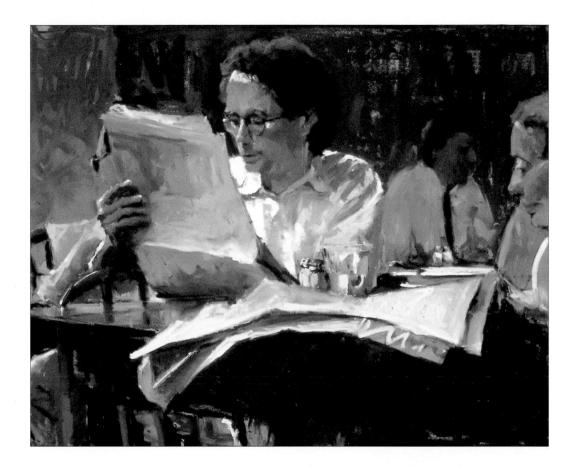

The Paper JODY DEPEW MCLEANE

Increasing the range of greys in your palette will help you to extend the tonal range. This painting is predominantly a study in tone, but the greys are varied, and the touches of colour in the skin and on the furniture bring the picture to life.

Still Life DEBORAH DEICHLER

Complementaries give us colour contrasts that are very useful when making a colour composition. Deborah Deichler's painting is mainly greens and greys, the greys tending towards blue in the mirror and on the wall behind. The greens are not sharp secondary greens but modified with white and also tending to blue. To contrast this she has used pink in the cups, the books and the roses. As a complementary to the blues in the background there is a subtle orange/ ochre in the bread rolls and on the edge of the open book.

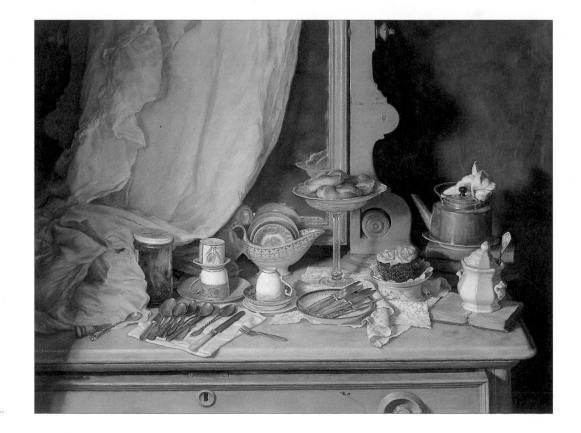

shadow colours

How can I make
my shadows more
realistic?

Study shadows –
they are never
black but filled with
a surprising amount
of colour and light.

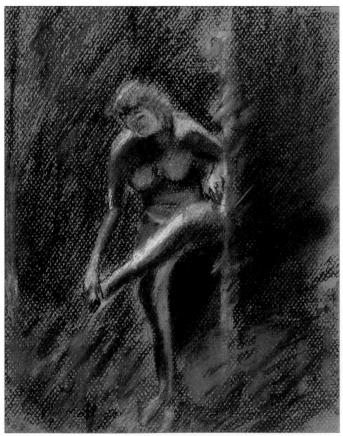

Student's version

the PROBLEM

Because shadows are darker than light-struck areas, beginners often render them as a blackish or greyish variant on the local (actual) colour. But if we look into shadows we can see that there is no black, and there is a surprising amount of colour and light reflected in them. The student has not looked, and has painted with opaque pastel, which looks as solid as the objects casting the shade.

the solution

By the 1860s the group of young French artists who became known as the Impressionists were assimilating lessons in colour from the works of Eugène Delacroix, who in his turn had learned from the English landscape painter John Constable. The latter had said that shadows could never be colourless; he could have gone on to say that a shadow is never entirely without light.

Complementary colours The Impressionists, to whom the effects of light were all-important, noticed that a shadow is not simply a darkening of whatever surface it is cast upon, and indeed is often a positive, identifiable colour. Their observation showed them that shadows tend to be the complementary colour to the object upon which they are cast. As I write I can see a shadow cast by a chair leg onto the yellow-blond wooden floor. It tends towards indigo/violet, while outside my window a tree casts a violet/grey shadow on the bright green grass.

Simplifying But there are other factors to watch for, particularly variations within shadows. Often a shadow will contain a lighter core because of light reflecting back into it from another surface. So the best advice is to observe very carefully and never assume anything. However, there is a danger of weakening the effect by putting in too much, so you may sometimes need to find a way of simplifying. Shadows in the background, for instance, may be teeming with visual information, but this could overwhelm a picture unless reduced. One method of seeing what is most important is to hold up a pencil and focus on that while at the same time paying attention to the out-offocus area beyond, which you will perceive as simplified colour masses. In a landscape, try focusing on the sunlit areas so that the shadowy places resolve themselves as simpler areas of colour.

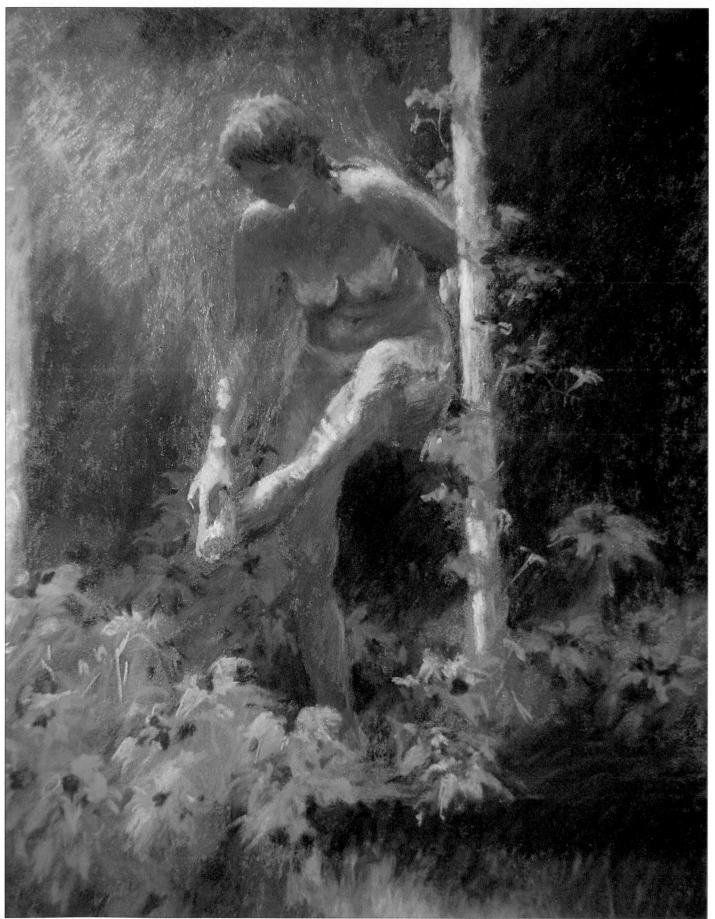

Bather by Rosalie Nadeau

creating HIGHLIGHTS

How do you make highlights look convincing? Mine look too solid.

Use varied colours
for your highlights
depending on the
lighting, the colour
of the object and
the degree of
reflectiveness –
don't rely solely on
white.

the PROBLEM

This arises from treating the highlight as a separate item instead of something that happens to an object or surface. Far too often, inexperienced artists put on highlights without really looking at the specific colour and shape, and that is what the student has done here; the highlights are dramatic but rather crude and act against the shape of the objects. The whole point of making highlight effects is to capture a subtle phenomenon, something that gleams and glints convincingly. The precise tone is important also.

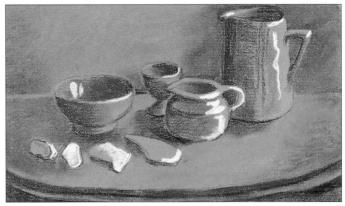

Student's version

It is tempting to reach for the white pastel, but not all highlights are white. Their tone depends on the colour of the object, the degree of reflectiveness, and the lighting. Bear in mind also that if you are working in natural light the highlights will change position during the day, so if you leave them until last they will not be in the correct relationship with the rest of the lighting.

the solution

When we look at a white jug, our intellect tells us that it is white all over, but in visual terms it will not be; it will be made up of a range of subtle colours depending on the light and any adjacent objects that are reflected on its surface. The highlights too will vary in colour, and may be relatively warm or cool depending on lighting and reflected colours.

Artificial light If you are attempting a still life with highlights for the first time, it is advisable to arrange it under artificial light so that you can avoid the problems of

Sideboard by Deborah Deichler

Highlight colour Even on the strawberries there are points of light. Note the difference in colour between those on the fruit and those on the broken edges of the china.

Light as highlight The light along the edge of this knife is quite subdued compared to the bright light on the side of the broken vessel in the centre of the picture, yet it still works as a highlight because the artist has correctly observed its relationship with the grey metal of the blade.

shifting light. Most electric lights have a yellowish cast, so your highlights will probably be varieties of warm white creams and pale yellows that are sharper than the surface around them. Deborah Deichler's still life is lit with a strong light placed on the same level as the objects, which gives an exciting shadow pattern as well as clear highlights. Note the subtle differences in the colours used for these. On the end of the central knife handle the white used is sharper than the soft highlight in the centre of the milk jug.

Natural light If you prefer working in natural light there are two ways of going about it. The first is to make a detailed drawing, annotated with colour notes of the light conditions as you want them, and work from both this and the group in front of you. Another method is to work directly from the subject, "chasing" the light as it moves. To do this you must work quickly and take care to keep your lighting consistent so that shadows and highlights work together. Highlights will occur on edges, high points and rough peaks and hollows facing the light source.

composing the PICTURE

Composition is about arranging what we see on the paper in such a way that it successfully conveys what we find interesting about the subject. It is a means of ordering the components of a picture, deciding where to put the various elements, and considering whether something should be played up, played down or left out altogether. This selection process requires thought, as it is possible to leave out the very things that give

a subject its uniqueness. I remember an amateur painter telling me how he had changed a rusty old iron gate that he saw into an invented five-bar wooden one. Sadly, in doing this he lost the opportunity for some much-needed colour contrast for his overwhelming greens. Putting a picture together, whether a landscape, a still life or a portrait, means that you have to think about the picture as much as you do

Practice

about the subject, making decisions before you start to paint. What viewpoint will you choose? And what format - a vertical or horizontal rectangle - will suit the subject best? How will you place the components within the rectangle - or square – you have chosen? There are as many different kinds of composition as there are subjects, but hopefully this chapter will give you some ideas and demonstrate a few general principles.

JODY DEPEW MCLEANE

In this seemingly spontaneous study, the artist has made a composition from a series of rectangles in which even the figure is constrained. The open music continues the line of her arms above the shoulders, strengthening the vertical contrast.

How do you decide on what is the best format for a painting?

the PROBLEM

When you are confronted with a landscape, a crowded beach or any subject full of interest the first problem is to decide on a format for your composition. It is very difficult to do justice to a promising subject if it is confined within an inappropriate rectangle. Deciding on a format requires careful thought.

the solution

You should take your lead from the subject. It is no accident that the horizontal rectangle is known as "landscape" and the vertical rectangle as "portrait". These shapes seem appropriate for those subjects. However there are plenty of exceptions to that rule. A portrait head may be painted in a square or, to fit in more than one figure, a horizontal format may be used. A view up a mountain or down a tree-lined avenue may demand a vertical format.

Choose the shape that shows off your subject most effectively.

Planning composition In

a scene like this there are many possibilities for compositions, it really is a matter of selecting something that contains what most interests you. 1 Foreground, middleground and background interest. 2 The middleground is the most interesting part of this composition. 3 Lots of foreground and background interest.

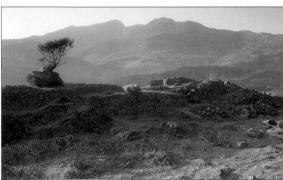

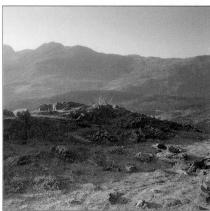

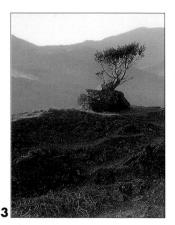

on the spot LANDSCAPE

Can you give any advice on coping with changing light?

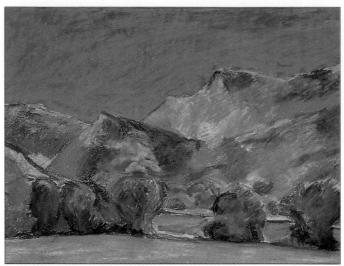

Student's version

Work out your composition beforehand then you can concentrate on capturing fleeting

effects of light.

the PROBLEM

This is one of the major challenges for the landscape painter. Even in the most settled climates shadows will move with the sun, and in mountainous regions where the weather tends to be unsettled the changes are very rapid and apt to alter the whole scene dramatically. The student has done what many inexperienced painters do attempted to keep up with changing light by making alterations as she worked, with the result she has lost the light - and hence the drama of the subject - altogether. The light appears to come from no particular direction, although since the sky is clear the sun must be present.

the solution

When you want to capture fleeting effects, the essence is speed, so you won't want to waste time over planning the composition and making a drawing. I solved the problem when I was working in the mountains of Southern Spain by doing this preliminary work the day before. I wanted to capture the light of just after dawn, so I went to my site the previous afternoon and drew up my composition lightly in pencil, but in quite a degree of detail, so that I could concentrate on the light and colour the following morning. If you do this you may find that some of the things you saw the previous day are invisible in the different light, so you must be prepared to change or cover over areas of your original drawing.

Another method is to return to the site over a period of days at the same time. I have a friend who has been working on a late-afternoon landscape in June for two years - not recommended if you are impatient for results.

When you become more experienced you will find that your visual memory improves, enabling you to retain fugitive effects of light that have since disappeared. There is always some element of memory in painting, as nothing remains exactly as it was when you first saw it, so try to remain true to your original impression. However, you should be courageous enough to radically alter a picture when something exciting happens in your landscape distant lightning, a brilliant shaft of light coming through cloud cover or a pattern of shadow cast by passing clouds.

Making changes as you work can be a dangerous business: a picture can easily become chaotic unless you start with a well-made composition, as Rosalind Cuthbert has in her mountainscape. The painting was done entirely on site, without preliminary drawings, using a limited range of blues and greens, with some pale pinks, a brown and a violet. The paper was already prepared with a coat of red gouache, so the greens and blues "sing" immediately without having to be heavily worked.

Above Lake Tenno by Rosalind Cuthbert

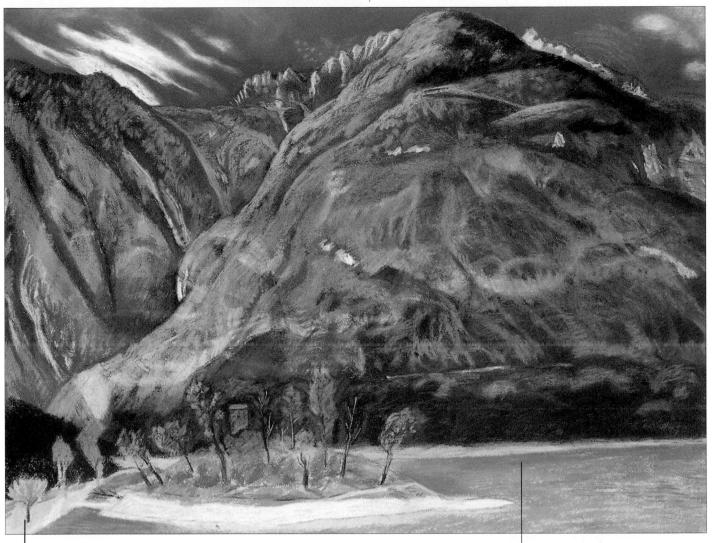

Tonal contrasts The use of tonal contrasts is very important in creating a convincing light-filled space. The blue trees glow gently in front of the dark slope. The green mountain edge is sharp against the blue fissured slopes behind.

Coloured ground Here the red ground can be seen quite clearly showing through the pastel. Also more red pastel has been added to the shadow area above the lake beach.

choosing a VIEWPOINT

I liked the landscape, but I haven't been able to capture it. How can I prevent my picture looking boring?

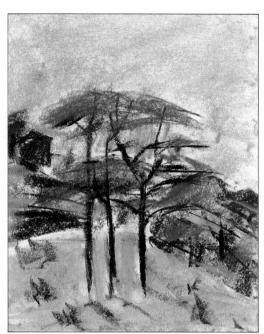

Student's version

Remember that a picture does not have to be symmetrical to achieve balance.

the PROBLEM

If you take landscape photographs you have probably noticed that an expanse of country that excites you looks dull as soon as you raise the camera and select one area of it. It is the same with painting, and the student's picture shows that she has been unable to find a satisfactory "slice" of the scene. This has resulted in a dull sandwich of sky, hills and fields where even the trees fail to excite the composition. All the principal lines are parallel to the edges of the picture, and they are all evenly distributed the sky occupies as much space as the hills, which are the same as the fields, and so on. The lesson is, don't paint a view unless you can see it has pictorial possibilities.

the solution

At the end of the 18th and beginning of the 19th centuries it became fashionable to walk in the countryside and appreciate the landscape. People even went so far as to carry an empty frame so that attractive scenes could be temporarily "framed" and enjoyed. Those sightseers would compete as to who could find the most "picturesque" or "sublime" view. Carrying a frame is cumbersome, but there is a much more convenient way of finding a view that will make a satisfying picture. A viewfinder, perhaps an empty 35mm slide mount, or a larger one made by cutting a rectangular hole in a piece of cardboard, can be a useful way of separating out a paintable composition. But it is better to allow for the possibility of other formats than the standard upright or horizontal rectangle; a landscape might benefit from a long, wide shape, a tall, thin upright, or a square. If you include two pieces of Lshaped card in your painting kit you can try many different proportions by sliding the two pieces against one another. I recommend about 23 cm (9 in) for the long arm and 10 cm (4 in) for the shorter one, but you can make them a suitable length to fit in your pastel box.

When you use your viewfinder, beware of choosing a view that is too "tidy" and self-contained. James Crittenden's Spain is asymmetrical yet well balanced, with virtually no straight lines, and only shallow space. The composition gains both dynamism and coherence from the way the tree trunks and branches bend and wriggle in front of the diagonal stepping of the skyline, cutting right across the picture area and going out of the frame at bottom, top and left side. The device of "cropping" often makes for a more exciting composition, so bear this possibility in mind when you use your viewfinder.

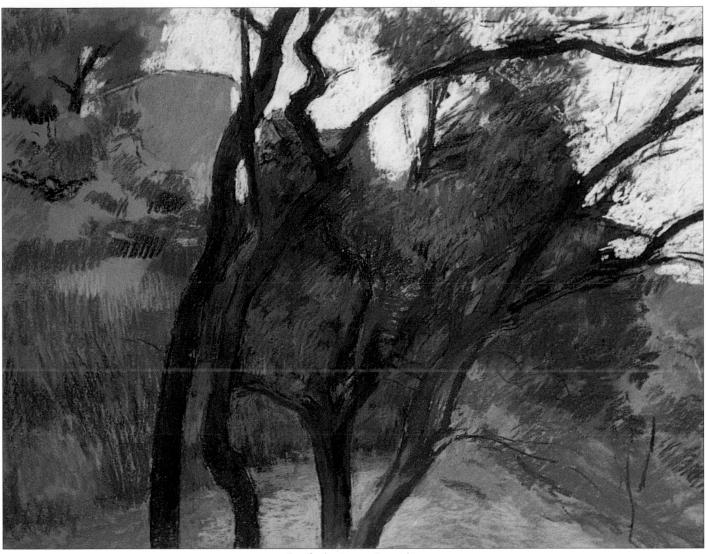

Spain by James Crittenden

Choosing a format

Choosing an appropriate format is an important part of the business of composing a picture; don't automatically accept the proportions of the paper you buy. Landscape does not necessarily have to be painted as a horizontal rectangle; try "portrait" format, or even a square. By using two L-shaped pieces of card you can frame your subject in different ways.

Portrait format

Landscape format

surfaces and EDGES

My pastel painting has a muddled, unfinished look. How can I bring things into sharper focus?

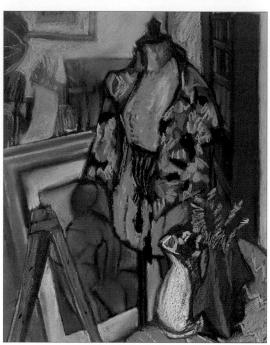

Student's version

With a complicated still life be selective with your focusing.

the PROBLEM

Striking a happy balance between the demands of the subject and the pleasures of applying pastel is something that the student has to learn. In this picture she has allowed the medium to overpower the still life. The arrangement is busy in itself, and has not been helped by such active mark-making. The muddled look is due to the fact that there are no solid surfaces; everything dissolves in a welter of pastel marks, except for the background which has been smoothed out until it looks soft and almost bland. A good composition can be easily spoilt by inappropriate handling of the medium.

the solution

A still life is an ideal subject for getting to grips with details, edges and surfaces. The lighting can be controlled, and you can get close in to the subject to examine the different surfaces. Also, of course, you can work on the painting for as long as you like. Unlimited time, however, can be a mixed blessing, as it is easy to overwork, with the risk of losing all freshness. I think that it is a good idea to set yourself a target, deliberately limiting the time you spend on a pastel. My picture opposite took about six hours - one session of two hours which established the composition and another of four hours when I concerned myself with colour balance, and the quality of finish which essentially means concern about surfaces and edges.

Surfaces Nowhere in my pastel did I blend using fingers, rags or any implement other than the pastel itself. So my work has that in common with much of the student's picture. The most solid-looking surface is that of the tailor's bust which has been achieved with soft pastel applied quite generously, covering the paper colour, except for the seams. I used a royal blue paper so that in the back wall I could allow some of its colour to influence the shadows. Other surfaces were treated to bring out their peculiarities - I looked for shine on the pink slip which was made with four colours, a magenta base over which I applied a pale magenta for the light and a red and a violet for the shade. The worn wooden struts of the child's easel were made with closely related umbers, with the scratches added with black conté.

Edges The nature of focus is largely understood by the quality of an edge. The sharper the edge the more in focus it becomes. With a complicated still life you may need to be selective in your focusing otherwise a picture's depth

Corner of the Studio by David Cuthbert

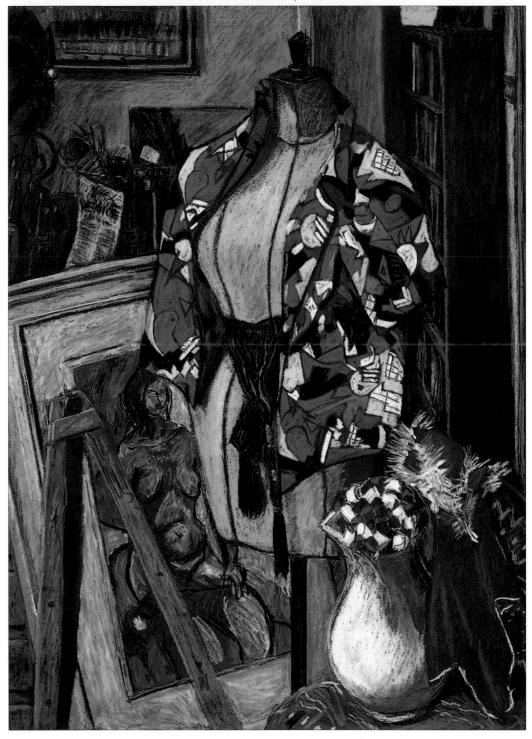

can be compromised. My painting contains a lot of different elements so it was important that I regulated my focus. The sharpest edges and greatest contrasts of colour and texture are on the tailor's dummy. The shirt is crisply laid against the bust, and the pattern of the shirt is sharply defined. As these shapes are small I used hard pastels which can be more easily worked into sharp corners. The nature of the edges change and become softer in the background, particularly in the shadow of the top left.

Using charcoal and conté

When you have established your composition you can use conté or charcoal to sharpen your edges or modify the quality of your surfaces.

Charcoal In this study of the tailor's dummy charcoal has been used to delineate the main forms.

Conté Conté is available in HB, B and 2B. 2B is the most compatible with pastel, and is used here in sanguine and black.

editing out DETAIL

I know I need not put in everything I can see, but how do I decide what to leave out?

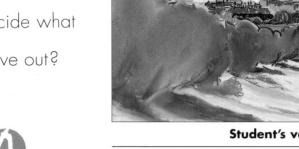

Student's version

Keep a clear point of focus and omit or simplify anything which does not help your painting. Practise selectivity by painting within a strict time limit.

the PROBLEM

This is never an easy question to answer, because it depends so much on the subject and the kind of painting you are aiming at. With a camera, it is easy; you compose through the viewfinder, press the shutter and you have a complete record of the scene, but a photograph is not the same as painting, simply because you can't select. In general, you should leave out, or at least simplify, anything that does not help the painting. Your picture, while being a rendering of a particular subject, has its own existence, and the student has failed to consider this. Uncertainty about what was most important in the scene has caused her to isolate individual features rather randomly, so that some trees and buildings are vague and others defined in a way that has produced a curiously disjointed composition. Also, by putting in too much background detail, the feeling of panoramic space has been lost, and this must surely have been one of the main attractions of the view.

the solution

To train yourself to be selective, avoid working from photographs (if you do) and take a leaf from the Impressionists' book, working on the spot and giving yourself a limited time. Impressionism began life as an art movement intent on recording the fleeting, the passing moment, the peculiarities of light. The Impressionists seldom if ever omitted whole features of a view, but they

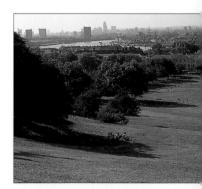

This photograph eloquently shows the difficulty of dealing with this subject. The foreground seems vast and the distant reaches of the river a long way off. If it is the distant city that attracts you as a subject you need to get closer.

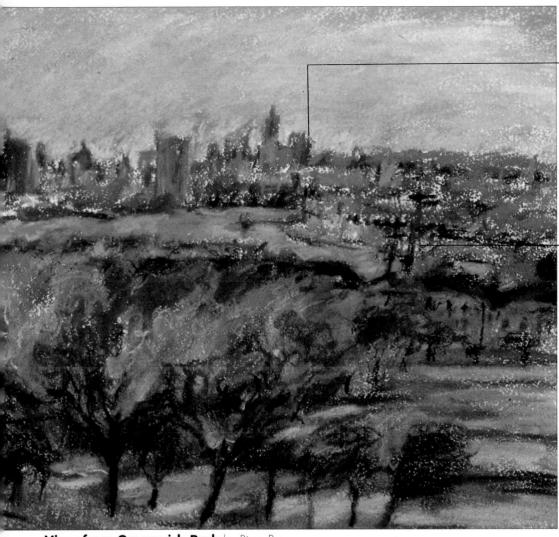

View from Greenwich Park by Rima Bray

Making comparisons

Here we can see the buildings melting into the hazy sky, which is a warm pale gold colour. Note how cold and grey the river is in comparison and how much sharper than the sky line.

Selecting detail The masts of an old ship (the Cutty Sark) are visible from the artist's viewpoint. Omitting them would have been false, as the ship is a local landmark, but they have not been drawn any more crisply than any other nearby feature.

did simplify, so that when the work was first seen many people thought it unfinished and raw; the ordinary viewer was accustomed to see highly finished and polished picturemaking, usually done in the studio from sketches. Impressionist painters also delighted in painting what was modern - the new Boulevards of Paris, the suburbs and cafés – and to capture the excitement and speed of modern life their technique had to be spontaneous, and they had to find shorthand ways of describing their subjects.

Rima Bray's painting is highly impressionistic, recording the quality of the light and the feeling of deep space - looking across to the City of London from high parkland, with the distant buildings merging into the atmosphere. She has not been tempted to put in precise detail in the foreground, as this would have given the area too much emphasis. The foreground trees are freely drawn, but with enough strong colour and tonal contrast to bring them forward in space. Unlike the student's picture, which changes focus arbitrarily, this has an overall consistency of treatment, with any change in focus in accordance with the effects of atmospheric perspective detail is always less obvious, and sometimes hard to discern, in the distance, so it can safely be omitted. Similarly the mark-making becomes softer and smoother as the eye proceeds into the picture.

Scale The strip of greys and ochres that make up the north side of the river accounts for less than a sixth of the whole picture area, while the trees and park occupy at least half. Scale rescues us from getting lost in detail. Once the dark tree on the left was drawn, everything in the distance had to relate to that and be in scale with it. While you might just be able to see individual windows in the buildings, there would be no point in putting them in unless you balanced this amount of detail in the foreground, with close attention to every leaf on the trees.

placing the subject

My painting looks so dull. How can I make a more interesting composition?

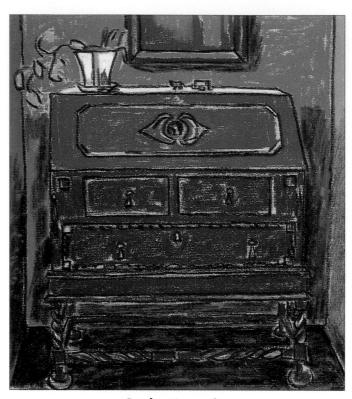

Student's version

Resist the urge to centralize your subject; over-symmetry makes a dull picture. Capture a feeling of life by varying shapes and the spaces between objects.

the PROBLEM

We all have the urge towards order, a desire to tidy things up, indeed one reason for making paintings is to rescue a little bit of order and stability from the unpredictability of life. Unfortunately this tendency can stifle and overcome the original feeling of excitement that we had when we first saw our subject. As gardens look more inviting if the flowers are not all planted in rows so it is with a painting. The capturing of a subject entails catching a sense of life. The student's pastel lacks life because everything is so constrained by the solid, symmetrical geometry. The picture might be useful as an advertisement for a furniture shop but as a painting it fails to intrigue us.

the solution

There is geometry in Sandra Burshell's painting The Study, but the bureau is not treated as a specimen; it is used for its pictorial possibilities. The artist has gone in close, chosen an unusual format in her tall upright rectangle, and kept her composition deliberately asymmetrical.

What makes this composition exciting are the horizontal and vertical divisions of the picture. The distance between each of those divisions is an interval, which can be likened to a piece of music. If all the intervals are the same the tune would be pretty boring, and the same applies to painting. Here horizontal and vertical lines are all unequally spaced; notice the simple way the pigeonholes at the back of the desk have been varied.

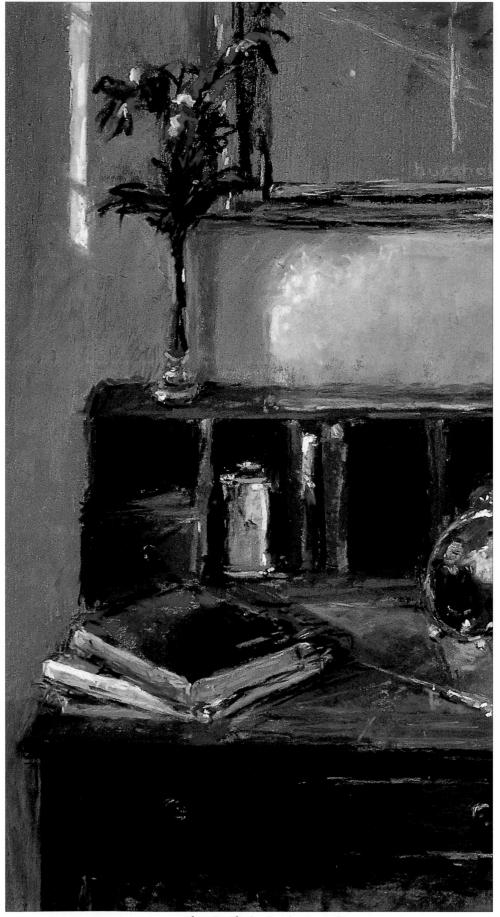

The Study by Sandra Burshell

Asymmetrical composition This diagram clearly demonstrates that an asymmetrical composition can be strong and stable. However simply you reduce this composition there is always the strong vertical offcentre core running through the plant and the nearest and furthest corners of the book.

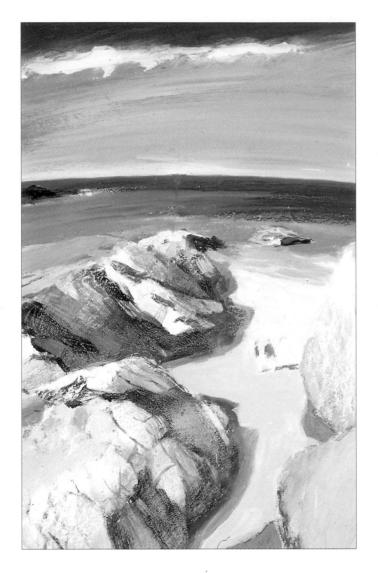

Scottish Tourist JANE STROTHER

In this picture the use of subtle variation in the "intervals" of the composition can be clearly seen. The black rock echoes in negative the cloud above it. The diagram demonstrates there is a strong off-centre interest.

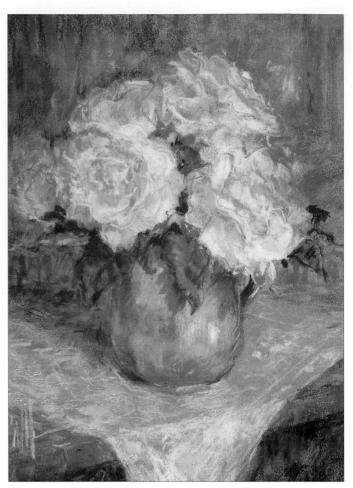

Peace Roses MAUREEN JORDAN

This largely symmetrical composition is not static because there is enough variation provided by the gentle diagonal of the table top and subtle ellipses of the rose heads either side of the centre line as shown in the diagram.

Despair SANDRA BURSHELL

To make the extreme asymmetry of the composition work, the large area of blue has to carry enough interest to balance the intensity of the face, but without being a distraction. This picture relies

mainly on colour for its impact. The head, even though it is so far up in the top left corner, catches our attention because it is the warmest colour and is at the end of the longest diagonal in the composition as demonstrated in the diagram.

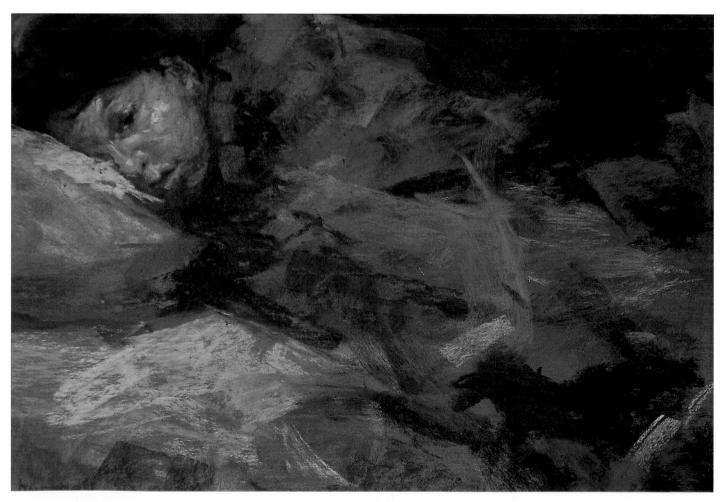

abstracting from NATURE

I'd like to turn my study of trees into something more personal. How do I go about it?

Artist's sketch

It is easier to interpret and not reproduce your subject if you paint from quick sketches containing only essential information rather than direct from nature.

the PROBLEM

If you work direct from nature it is difficult to interpret the subject, but if you make a series of sketches and then look through them later you may see other possibilities than simply a straightforward naturalistic picture. In the drawing of trees above, the lines emphasize the direction of growth in contrast to the swelling shapes of the ground. Always have a sketchbook handy. It need not be large; a small pocket sized pad is ideal for jotting down ideas wherever you happen to be.

the solution

This sketch contains essential information about the trees. The most striking and important lines and shapes were recorded. Now these have to be looked at carefully, without being too concerned about trying to remember what else may have been there when the drawing was made. If the drawing is a little unbalanced this may be something to improve upon in your pastel. In the sketch there are a lot of fussy lines and texture in the foreground which Jean Kent has eliminated in her picture.

Shape and colour The completed pastel has the quality of a stained-glass window, with the lines of the original sketch strengthened and used to divide the whole picture area into cellular shapes. The curving mounds out of which the trees grow have been simplified from the sketch, and in places swellings have been invented to preserve a rhythm in the rise and fall of the ground. The sketch was made using an ordinary pencil, with some written colour

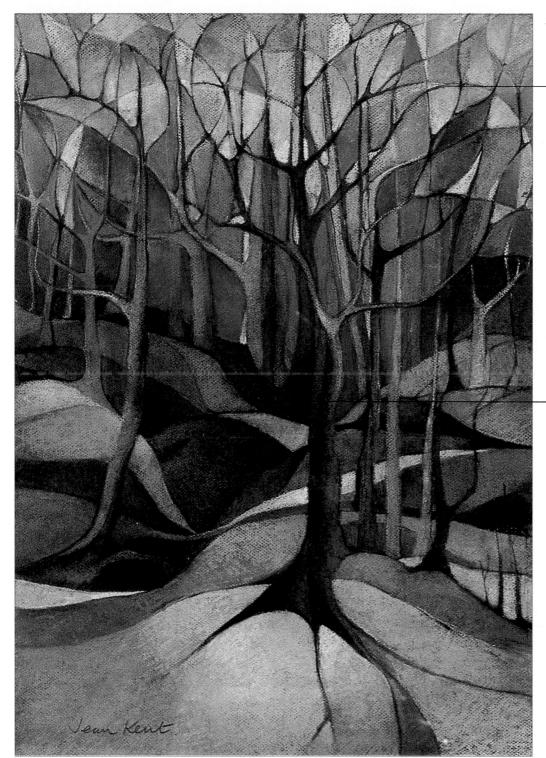

Composition

The twigs have been used like the leading in stained glass to contain patches of subtle green-grey and the blue of the sky.

Colour This is the densest part of the picture, where very dark and deep blues have been used. The artist has not been afraid to use black to get maximum depth of tone.

Trees and Bird by Jean Kent

notes. This allows for more freedom of choice than a detailed colour sketch; Pierre Bonnard's sketches for his paintings were usually pencil drawings - the colour came from memory and imagination. In Jean Kent's pastel the colour is used to reinforce a composition that is focused in the middle, and it becomes stronger and darker as it approaches the centre. The choice of colour - predominantly blues and greens - is intended to suggest those of a

wood in winter. Abstracting from nature is exciting because it allows you to express the feelings you may have about a place or a scene. A wood might suggest mystery, or the power of natural growth, or peacefulness, or timelessness. It is through your choice of composition and colour made by patiently listening to your own inner feelings that you will achieve a personal response to the subject.

Scribbly marks The orange rimmed black discs fill in the space where there should be sky. The pastel

marks are quite scribbly which heightens the sense of oppressive energy.

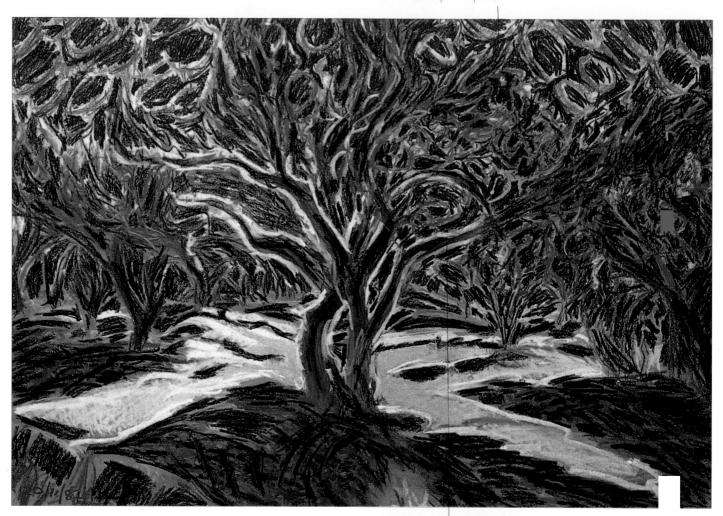

Olive Grove DAVID CUTHBERT

The artist and author has always found olive trees slightly sinister; the older they are, the more twisted and disturbing they become. In this pastel painting he let his feelings run away with him. The painting has not become completely abstract but has continued the twisting and turning of the trees right into any spaces where the sky is visible. To contrast with the

extreme agitation of the upper part there is a strong yellow "X" on the ground which retains the sense of surface and suggests depth under the trees.

Linear approaches The

whole picture is very linear. This detail shows the lines following the direction of the branches. The white line at the edge of the branches helps to release the tree from the others, as well as suggesting that the light is coming from behind. So we can see that the abstraction here is still based on close observation.

Developing an idea

In architecture the column and the capital are abstracted from the tree and its crown of leaves. Many of the patterns used on fabrics are abstracted from natural forms. The painter can also

This drawing was made on site looking out across a dell filled with trees and crossed with phone and power lines.

The first and second drawings were made from a wide variety of marks. This next stage has been treated more

flatly and the outline of each shape has become more important.

use nature as a source for imaginative and simplified picture making. These four images show the development of an idea from its origin as a sketchbook drawing.

The next stage, made in the studio, was to use colour and begin to simplify the composition. The "X" shape of

the crossed overhead wires was given more emphasis. Overall the colour is reasonably naturalistic.

The final version is a composition in which the flat shapes are strongly outlined and there are also marks

enlivening some of the shapes with a rich texture. The "X" shape has not been allowed to become too obvious.

dynamic composition

How can I make my paintings look more alive? This seems so wooden

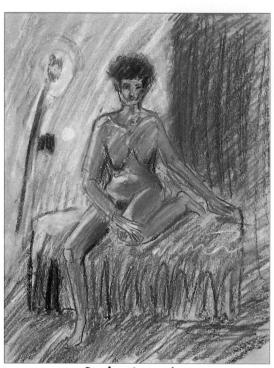

Student's version

Make your composition more dynamic by using an asymmetrical composition - set off diagonals against verticals and horizontals

the PROBLEM

Placing a figure - or arranging a still life if that is your chosen subject – is the first stage in composing a picture. If you are looking for a lively composition, arranging your subject very symmetrically, as the student has, is unlikely to succeed. She has tried to bring some life into the picture through her pastel marks, but these are not very meaningful, making the surface overworked and failing to disguise the dullness of the composition.

the solution

Asymmetry allows an artist to compose so that the viewer will be intrigued by the subject. An asymmetrical composition can imply instability, suggesting that things are capable of movement and change. Movement and energy in a picture does not have to be restricted to dramatic subjects where something is actually moving; the human figure, even when still, can arrange itself in ways that imply activity. For example, my pastel drawing Carole shows a model sitting in a pose that looks provisional, as

if she is about to move her left leg down prior to sitting more comfortably or standing up.

Direction lines The left- and right-hand edges of the screen behind the figure are the only verticals in the picture, and the dynamism of the figure, with bent leg and leaning torso is set off against those straight lines and the hanging leg, which forms a less straight vertical and shares a line with the edge of the divan. I have included a good deal of the divan, as this gives the figure a strong anchor, preventing the composition from becoming too unstable.

Pastel marks The problem with the pastel handling in the student's picture is that the movement of the marks bears little relationship to the shapes they should be describing. I have kept the pastel marks fairly open so that quite a lot of the paper still shows through, but the strokes relate closely to the shapes described. The lines simultaneously show the direction of each part of the body and suggest its surface.

Mark-making The

concentric lines around the artificial light are just one of the many different kinds of pastel mark employed in this picture to make it lively. The background is an important part of the painting, so don't let it become dull and bland.

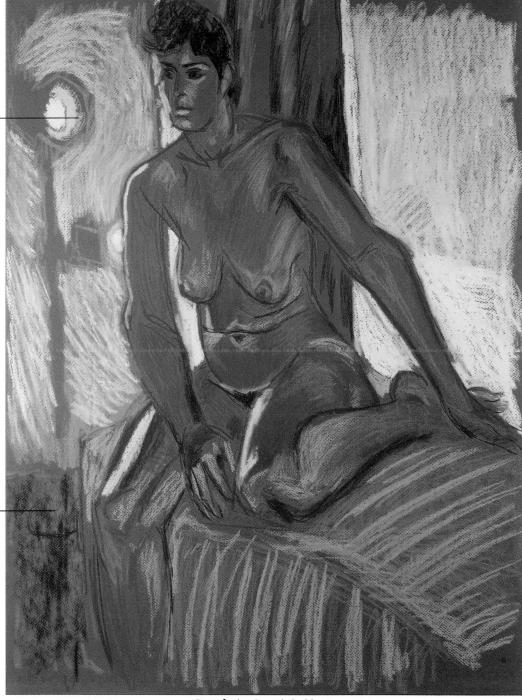

Broken colour Most of the marks are lines of different lengths and thickness, but here the artist has introduced some broken colour, using the side of a pastel stick to drag black over grey.

Carole by David Cuthbert

A palette of marks You should be continually widening your vocabulary of marks. These examples are made using the pastel point and side, and with varying degrees of pressure.

capturing MOVEMENT

I would love to capture movement in my work. Can you suggest how to go about this?

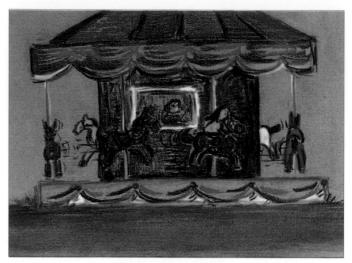

Student's version

Integrate your pastel marks suggesting

movement into the composition.

the PROBLEM

To render a moving subject convincingly requires a different approach from that of recording the likeness of an object. The problem is rather like that of the playwright's - we have to persuade the audience to suspend disbelief. We all know that the figure or galloping horse is not really moving, because paper and pigments are static, so we have to trick the viewer by implying movement. The student has not found a way of doing this, principally because his composition is so dull and the lines used to suggest movement are no more than afterthoughts. If you are to succeed with this, you have to think movement from the outset.

the solution

When something is moving, even at a modest speed, it passes before our eyes, changing shape as it does so. We see the front, then the side and then the back, so that we don't have time to take in all the details of the object. When there is local lighting as well, the changes will be even more dramatic, as the object will become more or less lit as it passes by. These effects can be seen in Elizabeth Apgar Smith's First Ride, which captures the thrill of the fast-moving merry-go-round.

Composition The artist has avoided placing the elements symmetrically, the big cylinder that is the core of the roundabout occupies one side of the picture, with the outwardly radiating divisions in the roof, giving us an understanding of the circular motion. An important compositional element, which adds a series of irregular vertical intervals, are the poles attached to the ceiling and each animal. The distance between each pole enables us to sense the space around the carousel's central drum.

Pastel strokes Unlike the student's picture the pastel marks suggesting movement are fully integrated into the composition. The strokes have been applied with diagonal hatching and crosshatching, an effective way of making the surface crackle with energy. This technique also makes the outlines and particular features imprecise, as can be seen in the giraffe's head and the children on the horse. The surest way to destroy the sense of movement is to use crisp details and edges, as these have the effect of freezing the subject.

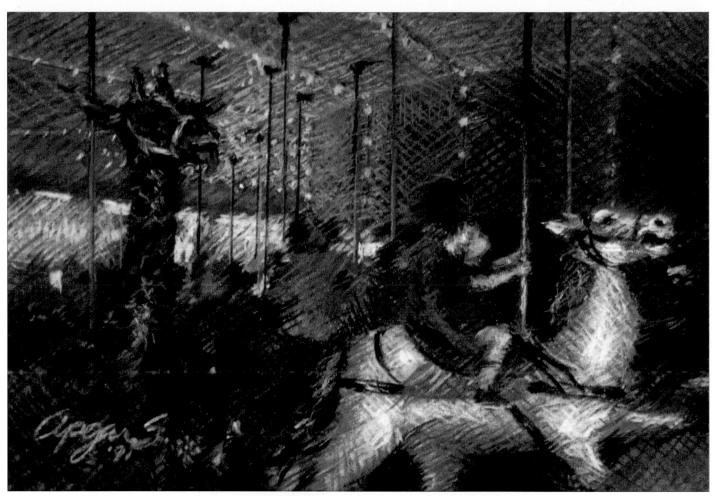

First Ride by Elizabeth Apgar Smith

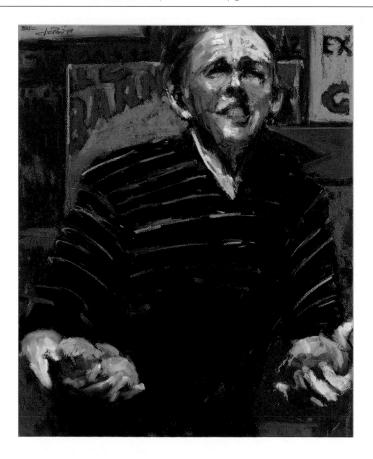

The Juggler JODY DEPEW MCLEANE

The dynamism of this image is an accumulation of pastel mark, tight composition, powerful colour and the expression of concentration on the juggler's face. Note how the only green in the picture (complementary to the background) is in the four balls at the bottom of the picture, while the juggler's eyes look up, perhaps for the fifth ball.

controlling a subject

I wanted to show the bustle of the market but my picture looks confused and bitty. What can I do?

Student's version

Choose a clear point of focus for your picture. This will draw the viewer's eye and give orientation to the composition.

the PROBLEM

A subject like this, with lots of figures in a space filled with all sorts of objects and colours, requires careful planning. The student's picture shows that not enough thought was taken before the picture was begun. The composition is awkward and does not convey much sense of space. Also the various elements tend to cancel each other out, each one competing for attention rather than working to produce a satisfactory whole. Complex subjects need a focus around which the composition can be built, but here there is no focus because the student has been uncertain as to how to select from the wealth of visual information.

the solution

In my dictionary of art terms, "focal point" is defined as the area in a picture to which the eye returns most naturally. The important word here is "naturally". The eye will follow lines in your composition, but if the lines are purposeless or confused the eye will wander randomly. In Jackie Simmonds's picture the eye naturally follows the lines of perspective to a point in the centre of the picture about one third of the way down, to the figure making a purchase at one of the stalls. Everything else in the picture is oriented around this figure, and the viewer's eye will always return to it, travelling around the picture and back.

Creating space This is another important key to the success of this pastel. The mass of market goods and stalls is set off against the empty space in the left foreground, while in the student's picture the choice of the landscape format has made it difficult to create this dramatic sweep from foreground to middle distance.

The strong foreground contributes to the sense of space, as we can compare the sizes of the fruit in the immediate foreground to those in the centre of the picture. The further away an object is, the smaller it will appear, with the boundaries between objects becoming less distinct. A common failing is to put in information that you know is there rather than what can actually be seen. If a background figure appears to merge with a tree, or another figure, let it.

Colour Another important factor in Jackie Simmonds's painting is its carefully controlled colour. While the student has become confused with colour because of too great a concern with the differences in local colour, she has chosen a dominant colour, which gives unity to the picture. The blue shadows, blue clothing and blue sky work to hold the composition together. The shirts are bluish white; nearly all the colours in the shadow areas have blue in them, even the pinkish-brown awnings.

Perspective The main scene is organized quite simply around a single vanishing point on the eye level. The awnings, because they are turning at different angles, will each have a different vanishing point. The best way to deal with complexities like that is to observe carefully. Don't get too trapped in elaborate perspective construction.

Foreground interest The relative openness of the

foreground is more crowded than might appear at first glance. One of the most intriguing things in this pastel is the strongly lit bale occupying space but barely present because the sun bleaches it so effectively.

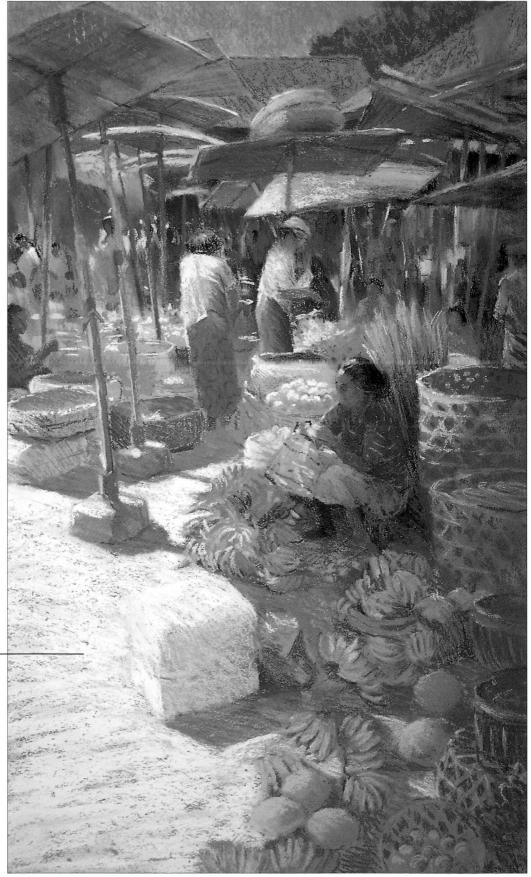

Ubud Market Scene, Bali by Jackie Simmonds

foregrounds in LANDSCAPE

I never know how much foreground to put in. And where does the foreground end and the middleground begin?

Student's version

There is no clear division between fore- and middleground; how much you include of each will vary according to your eye level and the perspective this gives.

the PROBLEM

This can be confusing because there often is no precise dividing line. Terms like foreground, middleground and distance have their uses; they guide us through procedures, but it is a mistake to think of them as exact descriptions of parts of the picture. However, the first part of the question is easy to answer - there is not enough foreground. The eye level is lower than half-way down the picture, which has not provided enough room to achieve a good sense of space on the ground. Also the marks used do not diminish sufficiently as they approach the horizon, so there is no feeling of recession. As viewers we need to feel that we can enter the picture, and walk from foreground to distance.

the solution

The viewpoint you choose – whether you stand or sit – has a direct bearing on your relationship with the piece of space which is your landscape, so when you begin, think of how you will "put your eyes into it". If you stand you will see more ground; the nearer to the ground you get the less you will see. If you were to lie on the ground, a blade of grass would cut through the horizon. In "Winter White" the artist's eye level was above half way up the picture, giving her plenty of room to put in a convincing foreground and enough space in which to make the pastel

Winter White by Rosalie Nadeau

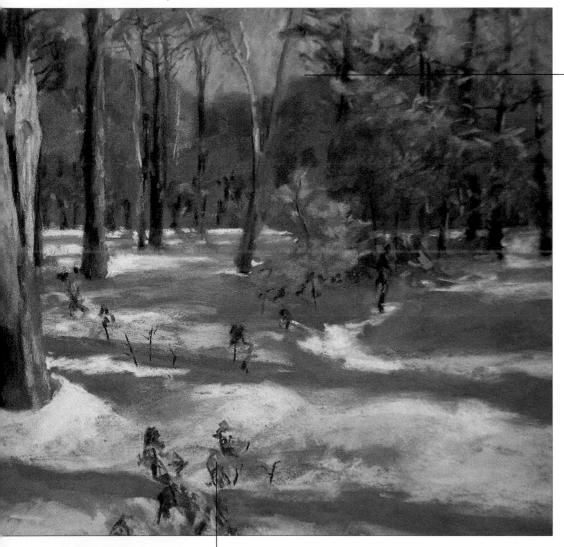

Perspective and depth

The perspective of the tree tops receding towards the horizon is an important factor in creating depth in this picture. They do not meet the eye level, as the trees form a screen at the back of the picture above the horizon.

Stroke work The warm pinky red of the dried weeds stands forward sharply against the pale and deep blues of the sunlit snow. Note the different directions of the pastel strokes.

marks diminish in size towards the background. She has also chosen her position in relation to the sun carefully, so that the shadows cut across the horizontal, making the expanse of ground visually interesting as well as providing an opportunity to exploit the uneven nature of the snow cover. By placing some dried weeds in the immediate foreground, she has given a sense of scale as well as pushing the middleground back in space.

We can imagine walking into the space to feel the weeds brushing against our boots, perhaps at about kneeheight. The tree stump has the eye level cutting through it so we know that our eyes are as high as that, therefore we can deduce the thickness of the trunk. All this is missing from the student's work, which is scaleless.

creating SPACE

My picture looks too flat - how can I give the impression of space?

Accurate

perspective will produce a sense of space: close objects should be painted in detail, those far away less defined and in softer colours

Student's version

the PROBLEM

Creating the illusion of three dimensions on a flat surface is a kind of magic. When the first paintings using the newly formulated rules of perspective were seen during the Renaissance the sensation must have been as exciting as when moving films were first seen. Perspective is often thought of as relating mainly to architectural subjects, but it affects landscape too, and this is something the student has not fully grasped. As things become more distant, they appear smaller, and the pastel marks must correspond to this. Here they do not; the strokes are too even and uniform, with the same marks used for both sky and foreground. Also, although the design is good, it is in conflict with the pastel colour and application. The colour is too strong overall, with each area of equal intensity. This, while it may produce a decorative effect, flattens the space.

the solution

The subject of Elsie Dinsmore Popkin's pastel is space. There are no hills, we are looking across flat openness, and the eye is irresistibly drawn to the distant line of dark trees. Everything in the picture works together to give us a light, air-filled impression, so that we have to make a mental effort to realize that this is simply a flat piece of paper covered in a coat of pastel.

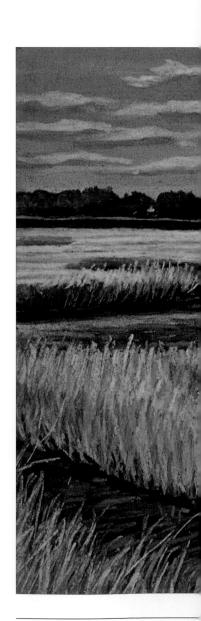

The perspective effects can be seen clearly; the detail condenses as it moves into the distance. We know that the expanse of water and reeds stretches for several hundred vards in front of us; but the reed banks and the water appear to close up, with the water becoming less and less visible, and the nearest reeds appearing several times taller than the distant trees.

In keeping with the diminishing size of the reed banks, the pastel marks are strong and broad in the foreground, but gradually become finer towards the horizon. The same treatment has been used in the sky, only more subtly. The clouds are finer, the sky milkier towards the skyline. Notice also how the curving ripples in the immediate foreground, drawn firmly and solidly, lead our eye to the V-shape of the reed bank, emphasizing the sense of space.

Creating space

This shows the detail and fine marks which are necessary when depicting the furthest distance. Compare

with the marks used in the foreground in the complete picture.

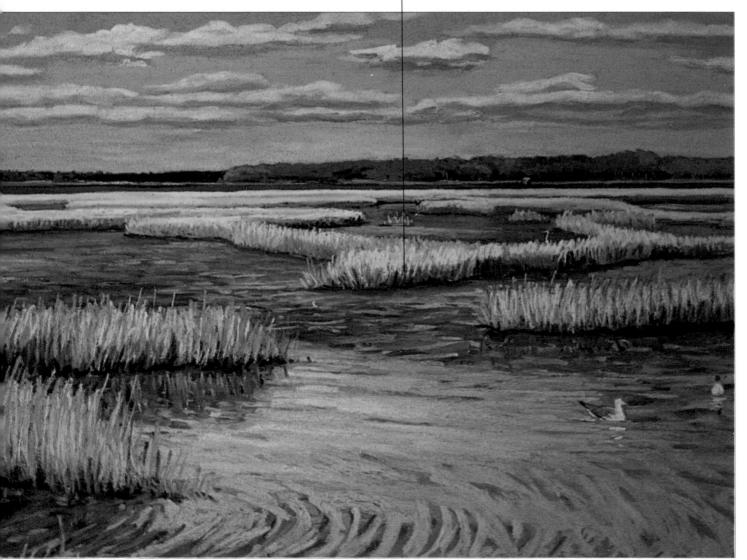

Ebbtide with Resting Gulls by Elsie Dinsmore Popkin

Snow Shore ROSALIE NADEAU

One way to create space in paintings is to use the effects of aerial, or atmospheric perspective. These are not obvious in Popkin's painting on the previous page, because there are no foreground greens to compare with the distant line of trees, but this picture is a very good example of the way colours become less dense and less contrasty the further away they are.

Thames Docklands PIP CARPENTER

The river in this vigorous pastel drawing makes a strong zigzag which takes the eve from foreground to distance. The detail is more specific in the foreground than the middleground, and towards the top of the picture, where land meets sky, the colour softens also. The grey paper was an ideal choice for such an image, as it allowed the artist to work with loosely packed pastel strokes, the grey serving as a base colour for water, ground and sky.

Bright Morning PATRICK CULLEN

In this picture, the road takes us into the scene – the eyelevel is such that we seem to be standing on it – and we are then pointed towards themore distant group of houses by the lines of ridges in the field. The distance is almost entirely confined to the space between the viewer and the sunny hillside, but the line of mountains suggests deeper space beyond.

Eye level

working from PHOTOGRAPHS

Is there anything wrong in painting from photographs?

Lighting The landscape may have been beautiful but the photograph does not make it look special. The composition is boring and the lighting dull. If the light is poor it is all the more important to compensate with a strong composition or a striking motif.

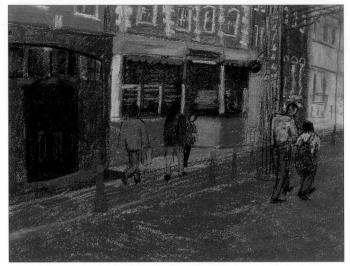

Student's version

the PROBLEM

There are people who regard the use of photographs as "cheating", but I have never understood why. It is in the painting itself that we judge success or failure, and photographs can help to solve many of the artist's difficulties. But problems can arise, because often there is insufficient information in the photograph, which leaves the painter having to either invent or slavishly copy. This results in something which is no better than the photograph itself and lacks the element of interpretation which marks a successful painting. This is what has happened here; the painting is rather flat and dull with large bland areas, but when you look at the original photograph you see the same featureless image. It has captured nothing really interesting, so why should the painting be any better?

the solution

The camera and its forerunner the camera obscura have been used by artists for at least three hundred years. There is a long list of distinguished artists who have benefited from the two-dimensional photographic image, whether in the form of a projection, as in the camera obscura and the modern slide projector, or as a photograph on paper. Eugène Delacroix, Edgar Degas and even Claude Monet

Not if you choose good photographs. They can capture wonderful fleeting moments and are useful memory aids - but take care not to copy them slavishly.

Street of the Golden Dragon by Doug Dawson

used photographs as source or for additional information.

But like all the tools available to the artist, the photograph has to be used with awareness. If there is too much detail, decide whether there are things you can leave out or simplify in the painting. Ask yourself whether you can improve on the composition, and whether the viewpoint is satisfactory. If you are taking photographs with paintings in mind, take more than one version of the same subject so that you have a wider choice of elements for the composition. If the colours look garish and untrue - skin particularly tends to come out badly in photographs - rely on experience and your memory of the scene.

The camera's greatest advantage is that it can capture a fleeting moment such as an unusual effect of light or the movement of figures and animals, so why not use it for what it is best at, as Degas did with horses, or as Doug Dawson has done in his painting here. This is a lively and exciting subject, with the camera lens selecting from a highly complex view. Imprecise areas have presented no problem, because detail is not important, and the whole image has been rendered with energetic mark-making that expresses the bustle and sparkle of the subject. Notice how the lettering on the shop signs has been suggested rather than rendered precisely so that it does not distract from the overall sense of movement and space. Similarly the figures have been generalized in a way that suggests their movement and changing positions against the strong lights and darks of the urban setting.

composing a STILL LIFE

My still life looks dull and unnatural. Any tips on how to arrange the objects better?

Student's version

Choose objects you respond to. and spend time arranging them. Then experiment with different viewpoints.

the PROBLEM

As the student has realized, there is more to still-life painting than creating a likeness of the objects. A good deal of the work is done before painting begins. Setting up a still life is similar to flower arranging, and both can easily become stilted and over-formal. The student has obviously struggled in trying to make an informal arrangement, but the objects do not relate to one another very interestingly and the viewpoint makes everything appear to stand in line. It might have worked better if the lighting had provided some atmosphere and depth of shadow, but it is too flat and even.

the solution

A still life gives you an opportunity to make an intimate little world over which you have some degree of control. It also helps you to practise your technique and pursue your own ideas about picturemaking. But to make a good painting, you must choose something you respond to. Perhaps your main interest is colour, in which case you might like to arrange fruit and brightly coloured pots, perhaps with some patterned fabric. Or perhaps you are intrigued by the effects of light and shade, in which case you could set up your objects under a spotlight that casts strong shadow, or put them on a sunny windowsill. You may respond to surface textures - Jean-Simeon Chardin, the great French 18th-century still-life painter, was interested in the physicality of his objects, and took great delight in depicting the particular qualities of metal, glass, ceramic, fur and fruit.

Design and pattern The student's arrangement, although far from perfect, could have made a more interesting painting if it had been viewed from a different angle, perhaps looking down on it from a standing position. Jean Kent's Still Life with Pomegranates is viewed from above so that the objects are almost completely contained within the cloth, making a strong design in which the liqueur bottle is central to the composition, with the fruit forming part of an arc, concentric to the bottom of the bottle. The ceramic bottle acts as a step beneath the dark space at the back right and the central bottle. Arranging a still life, especially if you are setting up one that several people are going to work from, is a branch of three-dimensional design. As you walk around the group of objects it should offer a number of interesting viewpoints. You can also explore the possibilities of pattern. In Jean Kent's painting the patterns on the cloth are echoed and reinforced by the pattern made by the objects; the interplay of irregular curves and circles creates an intriguing set of relationships. The whole composition is intersected with curves - the pomegranates curve around the base of the bottle while the two labels curving on its base contain a shape that is similar to the fruit.

Still Life with Pomegranates by Jean Kent

Subtle background This detail could almost be part of a landscape. The folds of the cloth have not been depicted very sharply and neither is there any great contrast in colour or tone. The background is not competing with the main objects.

Depicting cloth pattern

The pattern in the cloth is depicted more sharply than can be seen in the other detail which is further from us.

But even here the pattern has not been allowed to overwhelm the picture and distract from the overall composition.

Still Life with Fruit and **Paintbrushes** KAY GALLWEY

Making your own arrangements gives you the chance to explore the possibilities of pattern and texture. This pastel drawing is made from lines – the cloth stripes, the lines of the brushes, even the shiny vases have been drawn in strong line. But colour is also important in this patterning; the cleanest sharpest colour is confined to the fruit bowl and its contents, which form the picture's focal point.

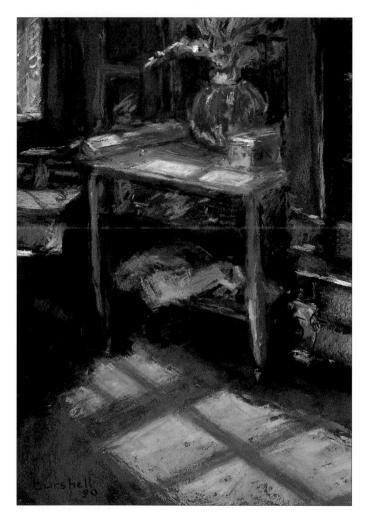

Warm Light SANDRA BURSHELL

You need not limit yourself to a group of objects on a table; interiors are a branch of still-life painting. This picture, a study of light falling across objects in space, is the kind of setting that looks as if it has been found rather than carefully arranged. The splash

of sunlight on the floor is as important as any solid object might be in the centre of a conventional still life. The objects on the trolley are treated very broadly. This is a small work, so each mark plays its part in describing an object, the light, or the shadow.

Setting up a still life

A still life does not have to be elaborate. A few simple objects are all that is necessary, and they do not have to be especially "interesting" or exotic. The interest lies in the way they are arranged and painted. Van Gogh made marvellous paintings from a pair of old boots or a rush-seated chair, so don't feel you have to find an expensive antique before putting pastel to paper.

Consider the relationship of the objects. Things can be placed so that you can play off colours or textures against one another, or you can bring in contrasts by clustering small objects around a large one. One very important feature that should not be overlooked is the space between things. These "negative shapes" are just as important as the positive ones of objects themselves. To a large extent still life is about ordering space into artistic arrangements. When you place the objects in your still life consider the shapes "trapped" between one object and another. Have a variety of relationships, try objects overlapping and with more and less space between them.

In this composition the objects are spread out so that there is almost no overlap.

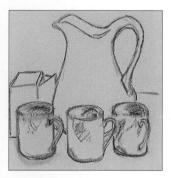

Here the objects are clustered together.

Now the negative spaces are more important than the objects.

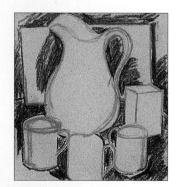

Here the objects and the spaces in between them have been arranged harmoniously.

backgrounds in STILL LIFE

My still life looks
very disjointed.
How can I make it
hang together
better?

Student's version

The background of your still life is an essential ingredient which will hold the whole picture together. Try not to regard it as a separate entity.

the PROBLEM

Still life is a little like portraiture (see pages 104-107), but instead of deciding what setting to put your sitter in, you have to decide where and in what way to arrange your objects. You must also consider the background and plane on which the objects rest. In the student's picture there is evident uncertainty as to how to deal with these spaces around the objects. The table seems enormous and the background is vague, reading simply as empty space and thus not contributing anything to the composition. You can often use shadows as a positive element in the picture, but here they seem like an afterthought and don't relate well to either the lighting or the shapes of the objects. But the student has been able to pinpoint the reason for failure, which is the first step to success in the future.

the solution

Thinking about making pictures has to involve the whole picture area. It is not enough to say "I would like to paint an apple", because an apple does not exist in a vacuum. I have a theory that the way we are taught to read in the West conditions us into thinking about things as separate items: i.e. A is for Apple, B is for Ball, and so on. Artists

Aerial Plum by Deborah Deichler

Highlights This detail shows the interaction between the objects and the cloth at its most complicated. Note the thin sliver of white between the leaf shadow and the leaf itself. The shadow is less dense as it moves away to the right.

have to think differently, to realize that objects are always in relationship with others and that they all influence one another. So when you are setting up a still life think of the background as a fundamental element of the arrangement without which your smaller objects will be meaningless. In Deborah Deichler's painting both the cloth and the shadows are essential to the success of the picture. There is a lot of space around the objects, but none of it is "empty"; the lace strips and creases all contribute to the presentation of the centre of interest. It is a very formal, almost abstract arrangement, and yet it is obviously a very realistic space containing real objects.

Design A still life does not have to include a large selection of objects to be interesting; many of the best still lifes focus on just one or two, as in this case. You could describe this picture as a portrayal of a plum, leaves and plate, but the cloth is both the background and the fourth object. It is also the largest one. What makes this succeed where the student has failed is the overall sense of design. The symmetry of the cloth provides a counterbalance for the asymmetrical arrangement upon it, with straight lines setting off the curves and circle of the plum, its shadow

Composition In a sense it could be said that the crease is an object, it has form, it catches light and it casts shadow. It is also an important compositional element.

and the plate and the geometry of the lace enhancing the organic shapes of the leaves by contrast.

The control of tone and colour cements the picture's unity. The plate is as white as the cloth and so acts as a compositional link between the cloth and the fruit. The red of the plum and deep colour of the leaves give us a satisfying tonal and colour contrast with the background.

Another thing the student has to face is the importance of lighting in still life set ups. Lighting does much more than simply letting you see the object clearly; it can create patterns of light and dark that can contribute to the composition. In Plum the light comes from above and slightly to the left, so that the shadows are thrown forward, creating shapes that echo and balance those of the objects.

composing a portrait

My portrait looks
very awkward.
Should I have put
in more of the
body? Or chosen
a different angle?

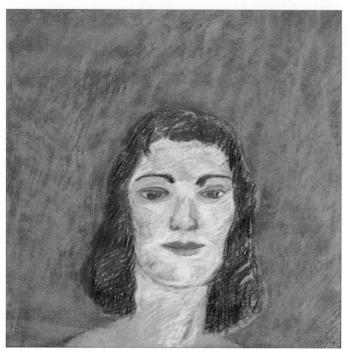

Student's version

the PROBLEM

We have seen how when you plan a still life you must think about the space the objects inhabit. It is the same with portraiture. By placing the head so near the baseline of the picture the student has made the bottom edge far too important. There is very little sense of space around the sitter's head and too much empty space above it. As often happens with portrait painting, the attempt to achieve a likeness has obscured the other concerns of picturemaking, so that although the pastel has a certain amount of charm it is not much more satisfactory than a photo-booth picture as a portrait. The way the face looks at us directly allows little scope for any suggestion of volume. Simplicity can often work in a painting, but in this case so many possibilities for telling us more about the sitter have been lost.

the solution

Even if you decide to paint only the person's head, a portrait is something that needs careful thought. The first decision to make is your own position in relation to the sitter. Is he/she going to sit while you stand or vice versa?

Keep moving around your model until you find an interesting view.

Make sure that your lighting is effective.

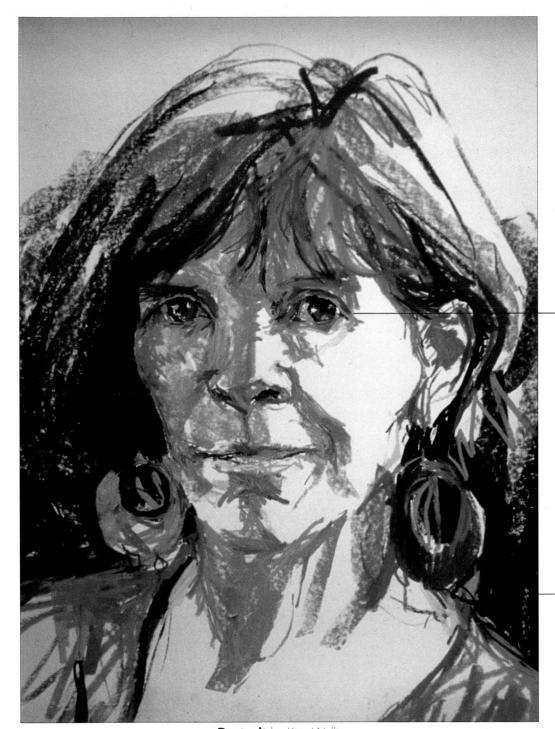

Natural focus The eyes are the most resolved part of this portrait giving it a natural focus.

Light and dark contrast

As well as white paper, which has been left in the most strongly lit areas, the artist has not been afraid to use black in the very darkest areas.

Portrait by Kitty Wallis

Or will you both sit, or both stand? Once more we are concerned with viewpoint. There is very little sense of viewpoint in the student's picture; all we can be sure of is that the artist's and the sitter's eves are at the same level.

It is not essential to show more than the head and neck in a portrait, but you must suggest the threedimensional forms, and viewing the head at a slight angle allows you to do this more easily. The nose, for example, will come forward from the face instead of merging into it. For her pastel drawing, Kitty Wallis has chosen a threequarter view, with the head strongly lit from the right.

This makes for an interesting composition in which contrasts of tone play an important part. The larger expanse of face is very brightly lit - most of this has been left as white paper, while the other side of the nose, in shadow, is more fully worked in colour. Both eyes are similarly finished, as they are both shaded by the brows. This is a simple composition in which the energetic and varied pastel marks convey a feeling of strength and life.

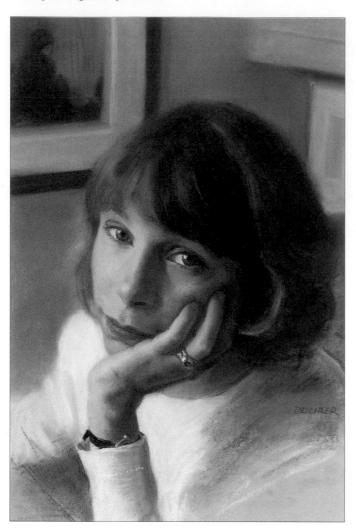

Sarah P DEBORAH DEICHLER

For this charming portrait, the artist has chosen to look down on the model so that we see as much of the top of the head as we do of the face. The pictures in the background, softly out of focus to avoid taking attention from the face, marks the space as a specific location relating to the sitter.

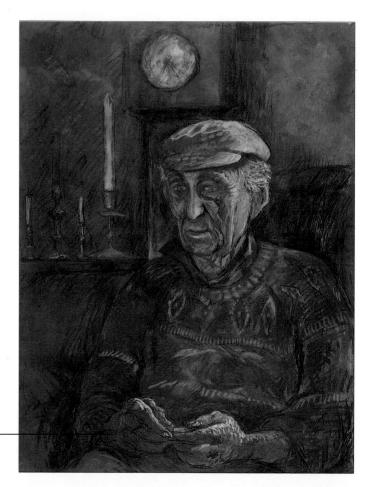

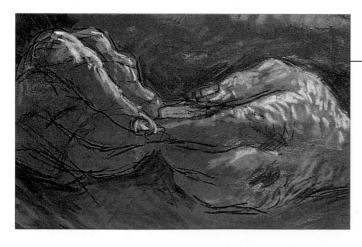

Tom at Home ROSALIND CUTHBERT

People in their own spaces have a special atmosphere, and professional portrait painters often insist on painting their sitters in their own homes or workplaces. In this portrait of a retired carpenter comfortably at

horne in his dusty pullover, it is not just the face that makes the portrait; his hands are just as full of character. This picture was done on a ground of grey-green gouache, and the composition was drawn first in charcoal.

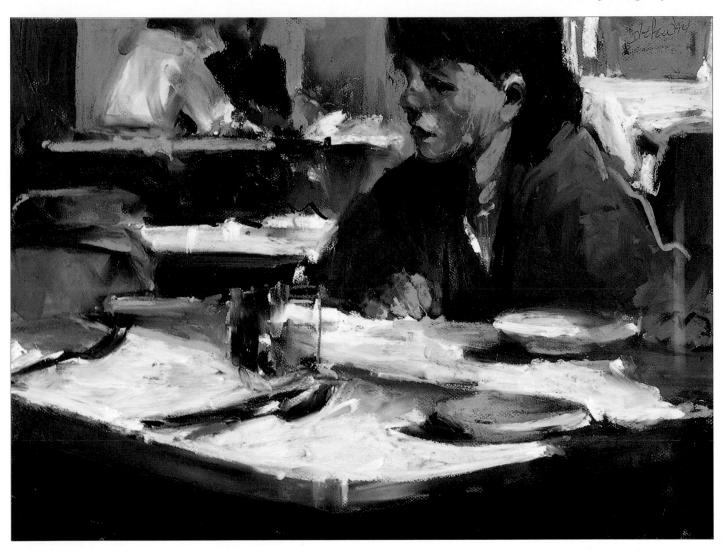

Brenda's Café JODY DEPEW MCLEANE

A portrait does not have to be a formal affair, and this is both a study of light and the atmosphere of the café and a record of a pensive moment in the life of the sitter. Notice how the heads of all three figures are cropped by the top edge of the picture, emphasizing the space that zig-zags into the café across the table tops. The uncertainty in the face is repeated in the gesture of the hands, tense against the edge of the table. The whole picture is in sympathy with the mood of the sitter.

Posing a model

Besides making sure that your sitter is reasonably comfortable it is very important to decide what kind of portrait you want. This checklist shows some of the questions you should ask vourself.

• Is the model to sit or stand? And will you choose a viewpoint from above, the same height or below? (Viewing from below will make the subject heroic, grandiose or oppressive. From above can make your subject look vulnerable. From the same level, your sitter will

seem more approachable and accessible.)

- Should the model make eye contact with you? (The most intense portraits are those in which the sitter appears to lock eyes with us. If the sitter is looking elsewhere this can give us the feeling that we are looking at something more private, even prying.)
- What kind of lighting? (The stronger the lighting the more dramatic the atmosphere. The most commonly used is soft sidelighting, which creates volume without creating harsh contrasts.)

- How much of the figure should you include? Just the head? Head and hands? The whole figure?
- Should the model appear to be engaged in some activity? (Ordinary and typical activities such as reading, sewing or knitting can strengthen a likeness – and prevent the sitter becoming bored.)
- What kind of clothes? Sunday best or casual? (The best answer to this is what is the most appropriate for your model, but sometimes it is fun to ask someone to sit for you in fancy dress.)

problem AREAS

Every time you pick up your pastels you do not have to start a complete picture. Take time to experiment with different effects. One of the most important sayings of an artist is "Let's see what happens if . . ." Spend time trying out different ways of tackling subjects and keep the results for reference. Allowing yourself to make bad paintings is important experience on the road to mastering a medium. Special

effects like reflections. moving water or clouds are problems in any medium so keeping a sketchbook of your various attempts, good and bad, will be very useful. Even your failures may give you ideas for other pictures. Even a photograph does not record everything in front of it, and what it does record is according to the light and focal length. The artist can make choices to bring out

other things - like movement, or colour.

Getting Ambitious When you begin a picture you do not want to be always repeating things you know you can do. So in choosing a subject try to stretch yourself that little bit further. The following pages give some help in approaching some of the more ambitious subjects; but the best subject of all is the one that really interests you.

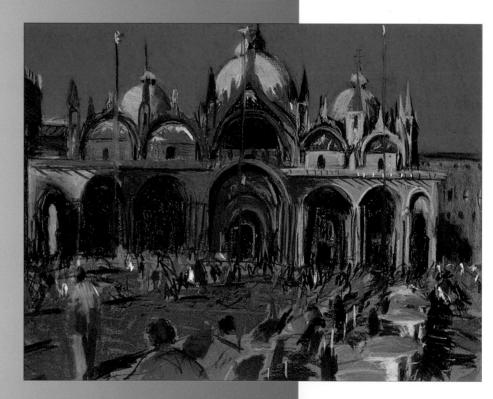

St Mark's Square, Venice SUZIE BALASZ

Suzie Balasz has simplified

her view of St Mark's Square, emphasizing the flurry of activity in front of the façade.

When I've made a mistake what is the best way to alter part of a picture so that my alteration doesn't stand out?

the PROBLEM

When working on a pastel painting there are bound to be occasions when you want to make alterations or corrections. There is no good reason why you should not erase and rework, but this needs to be done with care.

the solution

If it is still only lightly worked you may be able to erase most of the offending area by using a stiff bristle brush, or a putty eraser. A small piece of rolled fresh white bread also makes a useful eraser. The edge of the erased area sometimes can be rather harsh so be careful to soften the edge by using a brush. When you rework take care to match your colour and direction of marks with the surrounding pastel. Erasing oil pastel requires different methods. A rag moistened with white spirit will remove most unwanted colour. On the whole you will find it easier to remove heavy layers of oil pastel than those of soft pastel. If it is only small marks that you want to change a knife will lift out quite well.

The answer to this depends on how much pastel has built up on the paper.

Using an eraser to correct soft pastels

- 1 If you're not happy with an aspect of your work it can be corrected with an eraser, provided the paper is good quality.
- 2 Use a plastic clutch eraser to gently rub away the error.
- 3 Take care not to leave a hard edge to your erased area.
- 4 Having removed the top surface of colour from immediately around your alteration begin putting in your correction.
- 5 Use carefully placed pastel strokes to blend in the revised work
- 6 The corrected work.

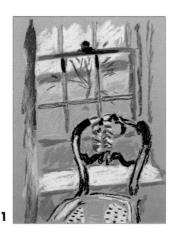

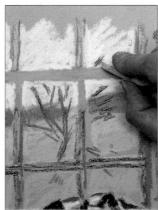

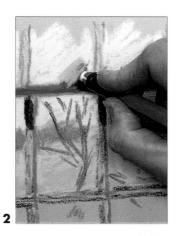

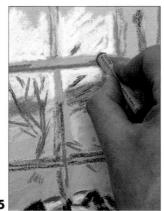

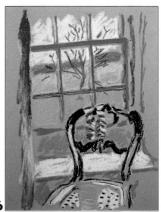

trees and FOLIAGE

How much detail should I put into my trees? It's so difficult to decide

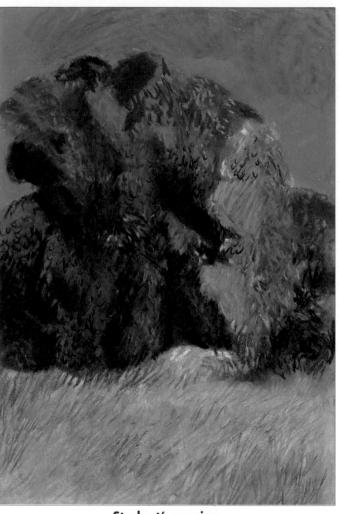

Look carefully at what the light is doing and don't put in more detail than you can easily see.

Student's version

the PROBLEM

Whatever the subject, artists have to decide what interests them most about it. This is not as easy as it sounds, because you have to stick with your decision as you work, during which time other interesting aspects may present themselves. This picture looks as though the student could not make up his mind whether it was the light he liked, making bold shapes out of the foliage, or the intricacy of individual leaf shapes. The sheer density of pastel strokes has also made the trees look very heavy; there is no possibility of light penetrating these matted surfaces.

the solution

If you find it hard to make out what is going on in part of your subject, perhaps in a shadow area, or in a place dazzling with light, then you have a good reason to simplify. You may know that there are leaves and branches deep in shadow but detailing them risks losing the contrast of light and dark.

Robert Maxwell Wood's painting is highly naturalistic and gives the impression of detail because of his use of small, flickering pastel marks, but the subject itself has been kept simple so that his interest in the light

Paper texture In this detail we can see more clearly the texture of the paper and the colour of it in places through the dark pastel. We can see also how the sky holes have been put in and then more pastel marks overlaid to keep the ragged edge of the leaves.

Painting grass Grass is a great test of patience and requires the artist to retain the softness and yet give it enough substance. There is enough variety in the marks to avoid monotony but not too much to create fussiness.

Trees by Robert Maxwell Wood

is not compromised. He has not overworked; even the darkest part of the large tree has been achieved with a minimum of pastel.

From dark to light With pastel, unlike watercolour, it is possible to put down dark colour and work light into it. This has allowed him to block in a dark greeny grey for the mass of the tree at the back, and then to use both lighter and darker strokes on top to describe the leaves tossing in a light breeze. He has also cut pale sky colour into and around the foliage at the top creating the characteristic feathery effect of a willow. Without "sky holes" the foliage will look unrealistically dense.

Scale of mark The band of closely worked grass in the foreground has allowed the artist to keep the strokes in the trees relatively simple. Because the texture of the trees is fairly soft, too much sharp drawing would be out of keeping, but the size of each pastel stroke must describe the relative sizes of grass and leaves. So the grass in the immediate foreground is drawn with longer marks than the furthest leaves.

Lakeside, Autumn DEBRA MANIFOLD

In this mixed-media oil and pastel painting, the artist has explored the abstract qualities of an autumn landscape. She has used the paint and pastel boldly and broadly, since it was the colour rather than the detail that most interested her.

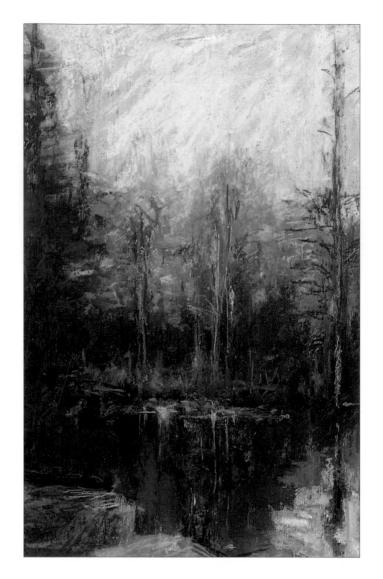

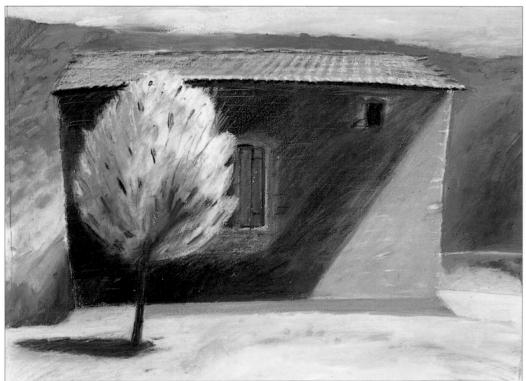

Gechena JANE STROTHER

This is another mixed-media painting, this time in oil and oil pastel. Here the simplification is to do with the strong Mediterranean light, which has suggested an almost fairy-tale image of a tree and a house.

Mark-making

Drawing trees and foliage is always a test of an artist's vocabulary of marks. The richness of a tree in its full summer finery challenges us to find convincing equivalent shapes, lines and textures, without depicting every leaf. Different pastel types lend themselves to particular kinds of marks.

Broad strokes Soft, semi-soft and hard pastels can all be used on their sides to make broad strokes, blocking in basic shapes. When you use the side of a pastel you can vary the pressure so that one end of your stroke is stronger than the other.

Scribbling The blunt end of a soft pastel will produce a slightly more linear mark than the side. This rough markmaking can be very effective as the basis for dense leaf cover.

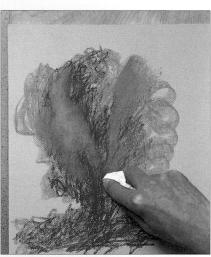

Smoothing out If you use a soft pastel for your initial scribbling you may put down too much pigment. If this happens, smooth out the surface with a soft brush or a cloth.

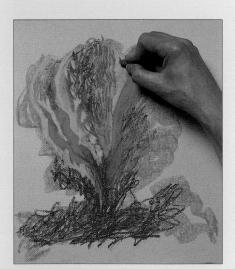

Sharpening up Once you have made the basic shape of your tree or bush you can add finer detail using a sharp edge of soft or hard pastel or a pastel pencil.

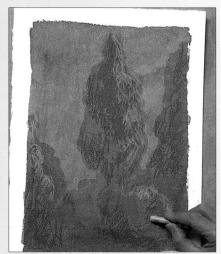

Coloured grounds If you want to explore foliage through drawn marks, try working on watercolour paper, blocking in the main shapes with watercolour, gouache or thinly applied acrylic and drawing fine pastel marks on top.

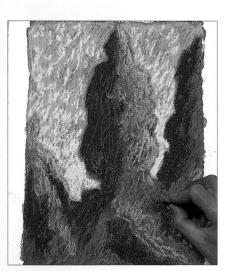

Texture The kind of mark you make will always be affected by the texture of the ground that you use. Watercolour paper, for example, will break up the strokes.

winter trees

I'm disappointed
with my trees –
they look so flat
and spindly. What
should I do?

the PROBLEM

The tree in winter is an attractive subject at which the student has made a brave attempt. The design is strong, but the branches of the large tree are rather too even in thickness, and are all on one plane, which is one reason why the tree looks flat. Another is that there is not enough difference in tone and colour between the base of the trunk

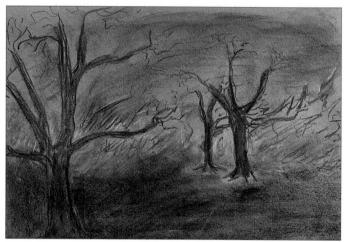

Student's version

and the outermost twigs. The reason for this may be that the student has been more concerned about the silhouette of the tree than in ways of showing the volume of the trunk, and the way some twigs and branches will face towards the viewer and some recede, moving forward or backward in space. Another problem is that there is little contrast of tone or colour overall, and this is the main cause of the student's description of it as dull.

the solution

Winter is not all grey skies, and Ray Mutimer has chosen to draw his winter trees on a bright, clear day. This has the advantage of casting shadows which not only help the composition but also give volume to the subject. Shadows are long in winter because the sun does not get very high in the sky, and here some unseen bushes, or perhaps buildings, create a strong shadow across the foreground and up the tree trunk, contrasting beautifully with the brightness behind. Notice also how the top of the shadow on the

Add volume to your picture by using a range of colours and tones and a variety of pastel marks. Use the strong shadows of winter light to create depth.

Building depth This detail shows quite clearly the range of marks that the artist has used. Several layers of colour give solidity to the foreground, from which diagonal lines of black cross the paper to form the upward thrust of the trunk.

Stroke work Fine strokes of black are sharp against the broad marks that make up the sky. The twigs and branches

have been drawn rapidly and spontaneously, without the clumsy heaviness of the student's work.

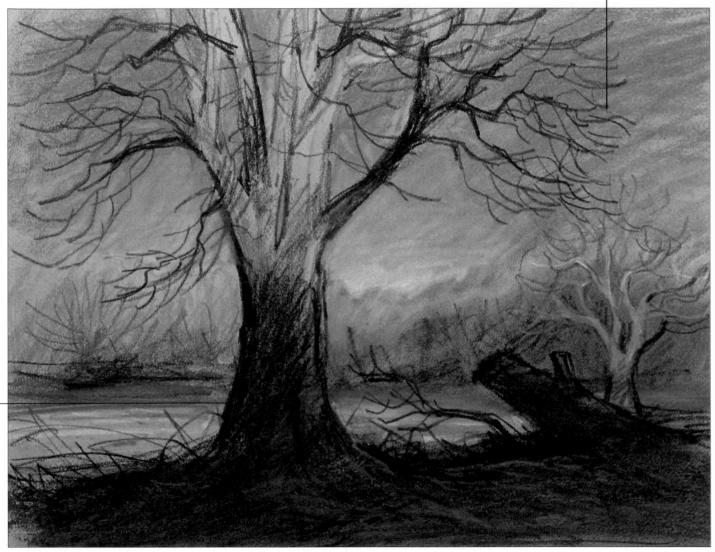

Evening by Ray Mutimer

trunk coincides with the tops of the distant trees so that there is an exciting dark-on-light counterpoint.

If you encounter visual events like this when working out of doors you will have to decide whether to use them in your picture or wait until the shadow has moved. In this case the artist has seen it as vital to the composition. Above the shadow line the tree catches the light so that it resembles a giant hand. Notice also how shadows and light catch different branches, continuing the pattern of dark and light.

Contrasts All paintings need some contrast, whether of tone, colour or shape. There are several kinds of contrast in this picture. The warm cream-coloured paper shows through, particularly in the upper tree and in the background trees, while in contrast the lower sky and foreground are densely worked with colour. The sky is the complementary opposite colour to the paper. And there is great tonal contrast between the foreground and middle distance, and the fine lines of the twigs contrast with the broad expanse of the sky.

cast shadows

I can't make the shadows look as if they belong on the ground; what am I doing wrong?

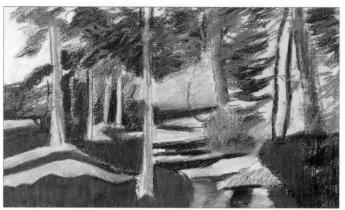

Student's version

the PROBLEM

Shadows can be a problem, particularly if you are working on the spot, because they move so fast. The usual mistake is to see them as something separate from the ground on which they are cast, whereas in fact they describe the forms beneath, and can tell us a lot more about the land-scape than a shadowless light can. The shadows in the student's painting are very hard, the edges regular and sharp, the darkness of them unvaried and flat. Another mistake has been to make the shadows too dominant a feature. You would need a very powerful light, with shadows cast on an even, pale surface, to produce this depth of tone and such crisp edges. The colours of shadows are influenced by that of the ground, and irregularities, hollows and changes in ground cover will all affect their quality.

the solution

A cast shadow is caused by an object blocking the light so that less of it reaches the ground. The shadow will reflect the shape of the object; for example, if it is a leafy tree casting the shadow the edges will be irregular, even on completely flat ground. Most commonly, however, the shadow will fall on an irregular surface, perhaps a field, where grass spears and weeds will break up the edge further. In Mary Ellen Pitts's forest the shadow in the foreground falls from the left across a mound, over a brook

Don't paint
shadows simply in
the shape of the
objects which cast
them but take into
account the shape
and colour of the
surface over which
they are cast.

Distant shadows There is much less contrast in the distant shadows than in the foreground ones, but the shadows cast by tree trunks in the centre are sharper than the edges of the shadow onto the mound.

and then up a steep bank on the right, and the quality of the edge changes radically as it moves across. On the mud it has soft rounded edges as it follows the bumps in the ground. On the water, which is almost flat, the edge is much sharper, while on the bank the grass and twigs make it spiky and ragged.

Keeping up with shadows The shadows tell us where the light is coming from as well as describing the changes in the ground surface. But that source of light moves, of course, so to deal with this, draw your composition lightly with pastel pencil or charcoal, fixing where you want the shadows to be from the outset. You can also indicate in each shadow area some colour as reference, just a few marks in the appropriate colour will be sufficient as a reminder. As the shadows move you will be able to mentally shift the colour information from its new position in the actual subject into the old position as recorded on your paper. As you gain in experience you will work more quickly, but if you cannot finish the picture before the lighting conditions have changed radically, come back and complete it another day.

Distance As you look into the distance the difference in tone between light and shadow will diminish, but there are sometimes occasions when a surprisingly dark shadow will be visible beyond softer ones nearer to you. This will be due either to differences in the density of the objects casting the shadows or to differences of distance between the shadow and the object casting it. Clouds can cast shadows across expanses of landscape, creating wonderful patterns and emphasizing the undulations of the ground.

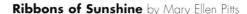

Shadows The mound is clearly shaped by the shadow, which is full of golden light filtered through leaf cover. Notice how much variety there is in the edge of the big shadow.

Shadows and tone

Shadows on water will often reveal much detail, and make the reflections easier to see.

There is a dramatic change in tone as the shadow falls across the bank.

sky and clouds

The clouds in my painting look so solid; how can I improve my skies?

Make sketchbook
studies of skies
whenever you can,
and be prepared
to record rapid
changes of shape
and colour.

the PROBLEM

The sky is always changing. Clouds do not remain the same shape for long, and their colours and tones vary enormously – sometimes they are darker than things on the ground. As the student has observed, she has failed to capture the insubstantial quality of the skyscape. It is not

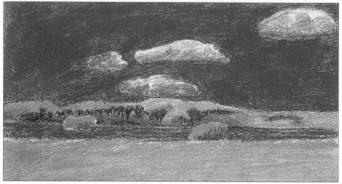

Student's version

only that the clouds look as if they are made of stone; the sky has no depth because it hardly changes from top to bottom. She has assumed that all clouds are white and grey, and the sky is blue, without really looking at what other colours there may be. As so often, the main problem is poor observation.

the solution

The great English landscape painter John Constable was one of the first artists to really look at skies. He kept sketchbooks of little cloud studies, painted out of doors directly from observation. This is very good practice; you can paint from a window if the weather is cold. There is no need to paint a whole landscape, studies of clouds and differently lit skies will be good experience, as well as providing a source of reference for indoor work.

Colour It is wise to have a good range of blues in your pastel box. The sky is not always "sky blue", there are often several kinds of blue in one sky. Collect blues of different "families" – warm ones that tend towards red, such as ultramarine, deep blues like indigo and Prussian blue, and cool blues that tend towards green like cerulean or even turquoise. Lois Gold has found more than one blue and a grey in her painting; the pale blue is distinctly cool and greenish, and the deeper one warm and purplish,

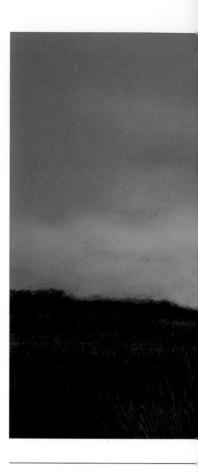

this line. A lighter sea might suggest haze and would close the effect of distance.

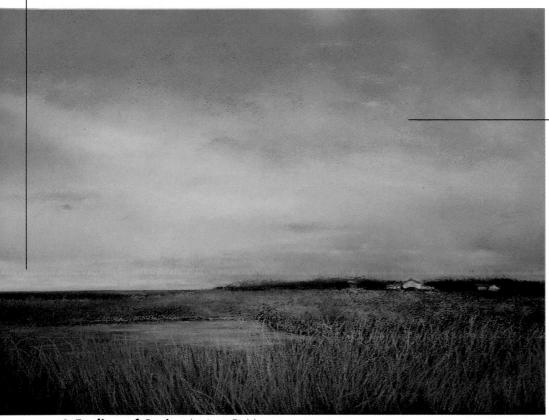

Suggesting cloud cover

This close-up shows us the light drift of creamy yellow which was all that was

necessary to suggest the orange light on the wispy cloud cover.

A Feeling of Spring by Lois Gold

with a purply red and a pale orange lightly drifted over it. What makes this sky convincing is the lightness of touch. The clouds have not been heavily worked, the soft texture of the orange cloud is from the first touch of the pastel. The densest colour in the sky is pale blue, which is a base over which all the other colours have been applied. Many paintings of sky fail simply because they are overworked.

Perspective Another failing of the student's painting is that it looks like a vertical plane. The rules of perspective apply to skies as much as to land. In Lois Gold's painting, the cloud masses become smaller nearer to the horizon because they are further away than those overhead. This rule of diminishing size will not always be evident, as for instance, when a storm cloud approaches. To make that convincing you must carefully compare the differences in colour between near and far clouds. Distant cumuli will be composed of many smaller parts that have gathered together, while nearer clouds of the same type will be made of fewer parts, so there will be a difference in scale. Distant clouds (those on the horizon) will tend to be paler

and show less contrast of tone – distance evens out contrasts. In *A Feeling of Spring* there is a sharp edge where sky meets sea, with a pale blue line of clear sky beyond the clouds, but if conditions are hazy, the horizon line may be indistinct.

There are days, especially in the damp north, when the sky is bright and hazy, and visibility is reduced. This is when water vapour hangs in the air, reducing the blueness of the sky. Shadows will be soft, and the shifts of colour in the sky are likely to be very subtle, but even so the sky will usually lighten towards the horizon.

Mood Skies are often dramatic and can contribute a strong atmosphere or mood to a picture. The 19th-century Romantic painters such as J. M. W. Turner used dramatic clouds to generate an atmosphere of awe, stressing the insignificance of humankind compared with the grandeur of nature. There is no reason why a painting should not be entirely composed of cloud and sky. Those who live in flat country will know that one of the great compensations is that the skies are so marvellous.

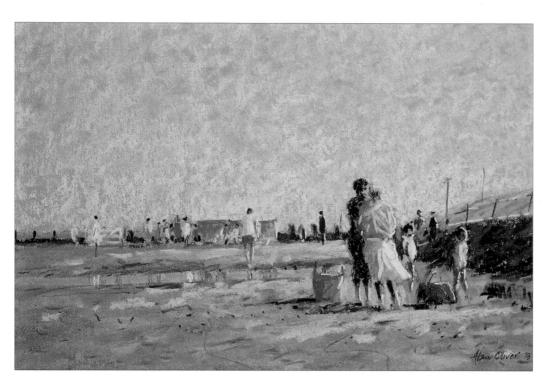

Beach Scene

This is a good example of the effect of haze making a sky almost like a wall, although there is a perceptible lightening towards the horizon. The artist has suggested the shimmering, insubstantial quality of the sky by using broken colour small strokes laid both side by side and over one another. There are three colours, the pale grey of the paper, a white and a pale blue all more or less evenly distributed

View of San Giorgio Maggiore, Venice MILTON MEYER

The effects of perspective are clearly observable in the sky of this picture. The great band of cloud is wider than the picture plane but tapers dramatically over the heart of the painting. The contrast between sky and cloud colour is greater close to than it is

nearer to the horizon. This is almost always the case, although there are exceptions; lighting conditions can play all manner of tricks, so careful observation is needed.

Creating clouds

Clouds are ephemeral things, so making them too solid will overpower a landscape. These two cloud studies show how

White paper Pastels are usually done on coloured paper, but they don't have to be. Why not try white paper, using the brightness and purity of the ground for the highlights? Clouds are often the brightest things to be seen in a landscape. The strongest colour has been applied on

the gaps between the clouds. To give the clouds volume touches of cream and grey have been used in one or two places.

different the sky can look even in unexceptional weather conditions. Studying and sketching the changing skyscape is an ideal way of developing your handling of pastel.

Coloured paper Anyone who has watched a sunset knows that clouds are not always white, indeed the colours can be almost unbelievable. A strongly coloured paper can help keep your colours rich; here a deep maroon was used. The densest colour has been

applied to the places where there is the most light. Areas of the clouds are left as the paper colour, but the strongly illuminated parts have been worked in reds, oranges and pinks. A deep purple has been used in a few places to deepen the maroon of the paper.

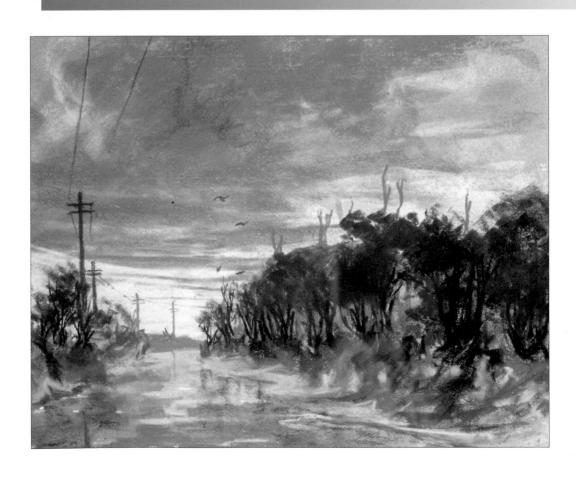

St Agnes Road, Cornwall LIONEL AGGETT

The sky takes up more than half the surface of this picture, and the mood is cold and sombre. The sweep of grey cloud is reflected in the road underneath, creating a cold, bleak image which is not contradicted by the warm rust colour in the trees. The swift spontaneity of the pastel marks – broad side strokes – keeps the picture fresh and alive.

Getting the
reflections right and
still making the
water look flat was
quite a problem.
How should I
solve it?

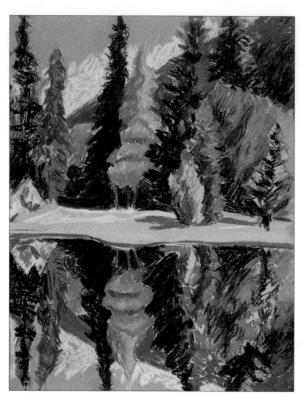

Student's version

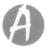

If the scene looks confusing, decide what you want to focus on. And don't be afraid to invent a ripple or floating twig to define the water surface

the PROBLEM

The eye presents us with a bewildering amount of information, and this is particularly true of water. In the stillest and clearest water you can see reflections, tiny ripples or particles on the surface, water weeds or fish below and perhaps stones and debris on the bottom. Choices have to be made. You could try to depict everything but if you do you will run up against severe problems of focus. If everything is equally sharp you will lose the sense of surface and sense of depth. The student's picture shows the confusion which can arise if you try to put in too much information. You may be able to see all of that but not without changing focus several times.

the solution

The best advice when attempting this subject for the first time is to limit the scope of your picture, taking a small piece of the view with just a few problems to deal with. In Deborah Christensen's painting we can see a straightforward approach to the subject. She has achieved the reflection and the sense of surface to the water quite simply. It has helped that the water is utterly still so that she has not had the problem of ripples to interrupt the reflection. It is the patches of floating scum that tell us that we are looking across a flat reflective surface. The diminishing sizes of the patches as they near the bank gives perspective to the space.

The reflection has been painted with a softening of edges by blending, and with less colour and tonal contrast than the scene above the water. Where there is crispness in the water is at the edges of the patches floating on the surface. The contrast between those pale ragged shapes and the soft depth of the reflection is also maintained by the difference in pastel stroke, which emphasizes the vertical dimension in the reflected image and the horizontal in the patches.

Mountain Serenity by Deborah Christensen

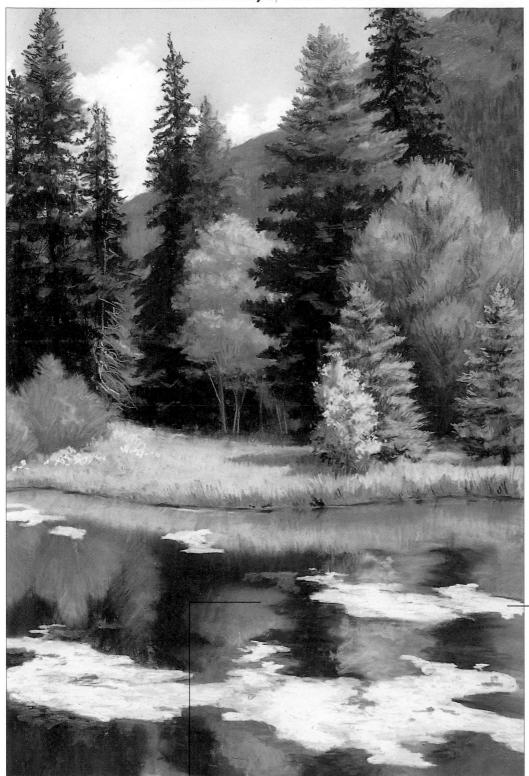

Edges The main contrast in this detail is between the floating scum and the reflection under it. The quality of the edge is much sharper than that of the edges of the reflected trees.

Reflections This detail demonstrates how much is lost in the reflection. Above water we can see more land between the water's edge and the trees at the back. We cannot see the fine trunks of

the little pale tree towards the back. Notice too how much softer is the reflection of the pink twiggy tree.

Lake Katrina – September Triptych ELSIE DINSMORE POPKIN

This ambitious pastel painting is well worth studying for its treatment of reflections. The indications of the surface of the water have been kept to a minimum – just a suggestion of tiny floating objects and what might be an eddy towards the back of the central panel. There is some intriguing "stretching" of marks and shapes in the reflection, particularly noticeable in the right corner of the centre panel.

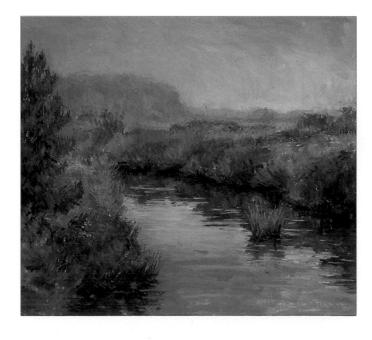

Foggy Morning on the Pamet

SIMIE MARYLIES

This is an interesting example of how weather conditions can affect the balance of reflection and the thing reflected. This misty but bright light gives more contrast in the reflection than above. The main contrast is between the bright sky reflection and the reflected tufted bank. This is more striking here than in the rest of the landscape.

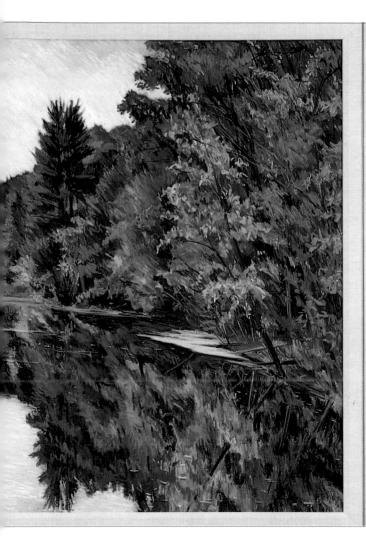

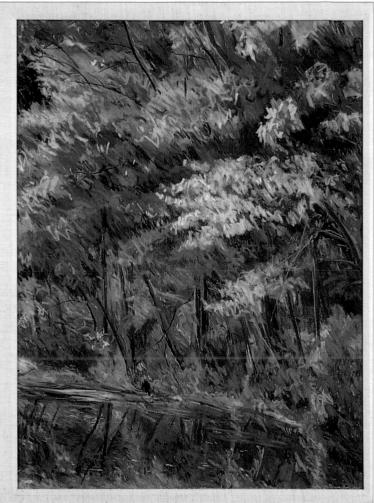

Tips for painting still water

- If you show the objects being reflected as well as the reflections you should notice that the contrasts will be reduced in the reflections, with the darks lighter and the lights darker. So when you begin to organize your pastel colour look for groups of colours that are close in the scale of tints. For instance, if you use a tint 8 for a dark colour above water use a 6 or 7 for the reflections.
- If you have a limited range of colours, paint the reflection first using unmixed colour then paint the scene above water

by mixing; the extra physicality will make it look more substantial than the reflection.

• Absolutely perfect, undisturbed reflections are rare, usually there is a small breeze at least which will cause ripples to break the edges of any image. Even if your image is unbroken when your first see it at some point a fish will rise and cause a ring of ripples or a puff of wind will move your reflection a little. It is worth including some evidence of the surface of the water otherwise your picture will look very static.

moving WATER

I did this from a photograph, but the ripples don't look right. Where did I go wrong?

the PROBLEM

Moving water is a very tricky subject; the difficulties of painting the movement of shadows across a landscape seem simple in comparison. Change of light is just one of the problems. Recording something moving, on a static surface, has always been a challenge to artists. Even photographers do not find moving water an easy subject, which may be one reason for the student's failure. The camera "freezes" the subject so that it looks like suspended animation, and if you copy the effect you will

Student's version

not portray movement effectively. Early photographs, using slow shutter speeds, recorded moving water as a kind of soft mist, which at least had the merit of suggesting movement. The student's painting shows a collection of hard, contrasting marks that are far too solid, so that the transparency of water is lost and the sense of movement compromised.

the solution

It is best to avoid photographic reference, or if you have to work from a photograph, spend some time watching water before taking it. You will begin to see patterns in the way the water curls around a shape such as a rock, and this will help you to simplify in your painting.

Jackie Simmonds has looked for the main movement in *Crystal Waters*, and used precise pastel marks to describe the way it swirls around the rock on the left. The weeds just beneath the surface, too, are waving very con-

Photographs tend
to "freeze"
movement so try
not to work from
them exclusively.
Instead, watch
water over a
period of time to
discover its patterns
of movement.

Crystal Waters by Jackie Simmonds

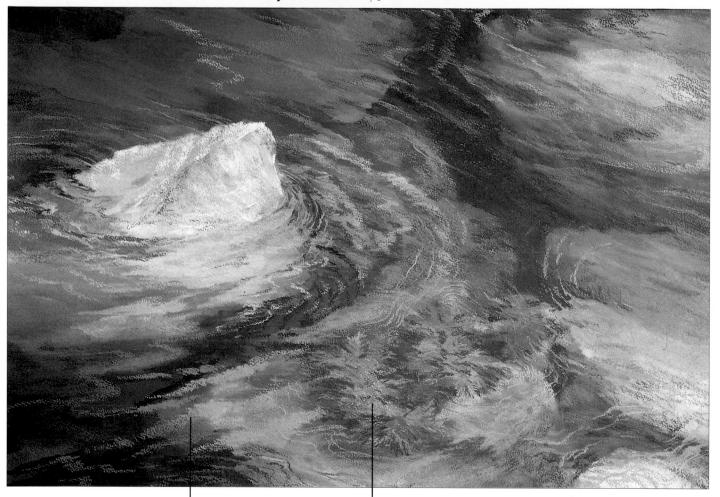

Movement This is an excellent example of how subtly and simply water can be treated and still convey a very convincing sense of movement.

Creating contrasts

Against the blue greys of most of the water, these feathery greeny oranges provide a

contrast. The edges of the leaves are kept soft so as not to jump forward and break the surface of the water.

vincingly. There is contrast, notably between the sharp rock and the water, but the overall impression is one of subtlety, carefully chosen tone and control of the medium.

Tonality Students often get confused as to the relationship between tone and colour. Unless you work in black and white colour and tone are inseparable; the word tone describes the darkness and lightness of a thing, regardless of its colour. When we talk about close tones we mean that there are no sudden jumps from dark to light, and you can see this subtle modulation of tones on the right of the picture, where there are submerged stones. This allows the area to be understood as objects beneath the water surface, but it is not monochromatic because among the greys are touches of pinks and oranges. There are stronger contrasts of tone in the centre, where the light-catching eddies move across the deep water.

Variety of mark Where the water touches the island rock there are very fine lines made with a sharp edge of pastel, while further away it has been used more bluntly but still with a light touch so that the tooth of the paper breaks up the line and prevents it from becoming too hard. Much care has been taken to vary the marks, which follow different directions. Around the submerged weeds there are broad marks, with very fine ones wiggling diagonally across them to give the impression of the weeds gently stirring the surface.

I've used a lot of white, but my picture doesn't really look like snow. Any suggestions?

the PROBLEM

Arctic explorers and walkers caught in blizzards complain of snow blindness and "white out". Unfortunately the student appears to have caught something of this, all sense of space and the surface of the land have been lost in unremitting whiteness. And because there is so little contrast of colour or tone the picture looks bland and uninteresting, failing to conjure up the feeling of awe we feel when

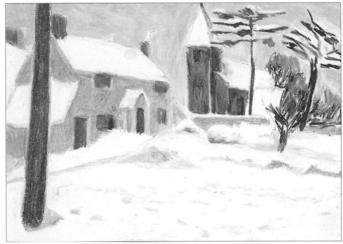

Student's version

we see a familiar place so utterly transformed and eerily silent. As artists it is not only our ability to record visual facts that is tested, but also our powers of expressing what it felt like to be there. How can one express that kind of experience and still keep within the bounds of realism?

the solution

One solution to this problem is to open up the pastel box and use all sorts of colours in an attempt to catch glints, reflections and other fugitive effects. Under a blue sky you can certainly see many colours in snow. But while this may produce a superficially attractive image it will not catch the density of deep white snow or the feeling of that cold white carpet under a leaden sky that promises more to come. In his oil pastel, Robert Maxwell Wood has taken the opposite approach by reducing colour to a minimum. He has captured the richness of fresh snow by giving us contrast – something to compare it with – an element missing from the student's work. He has composed his picture so that the dark walls of the outhouses act as a powerful foil for the snow, which in fact is far from being

When there is very little colour look for tonal contrasts, and also for the subtle colour to be found in glinting light.

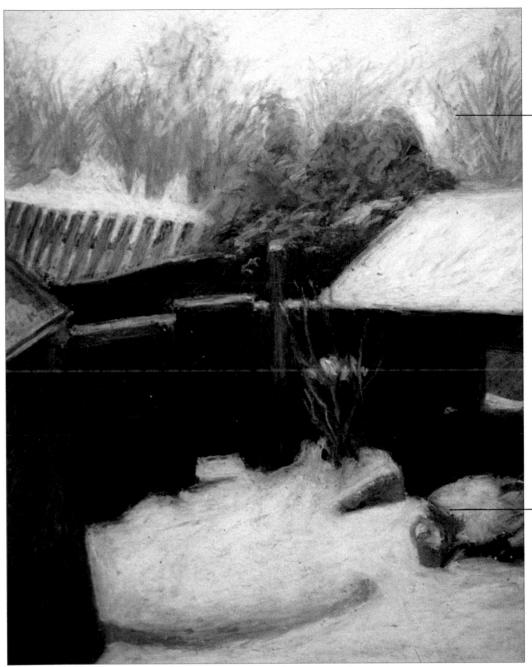

Backyard Snow by Robert Maxwell Wood

Softening strokes The strokes used for the trees have been rubbed over with the diagonal strokes used for the sky, which softens the effect of the branches and suggests snow still falling or to come.

Contrasting colours

Touches of warm colour, such as the reddish patch behind the watering can, enhance the overall coldness of the colours. Note the quality of the edges, the relative sharpness and softness, with the sharpest contrast against the wall.

pure white. In the background a row of trees is disappearing into the snowy sky, and the relationship between the softness of these trees and the sharpness of the walls, fence and the bottom edge of the white roof creates the space in the picture.

The medium of oil pastel, which is creamy and smooth, is ideally suited to the subject. White oil pastel picks up fragments of other colours, and this helps to emphasize the direction of your colour. Note how the marks in the foreground give an indication of the way the snow has been blown across the yard.

Tone and colour A heavy fall of snow turns the world into near-monochrome, and this picture could be described as monochrome - a composition of whites and greys. Yet there is colour: the tree behind the roof is bluegreen, the more distant trees have a yellowish tinge echoed in the foreground snow; the dark walls contain red and green, and a touch of orange glows behind the watering can on the right.

painting Buildings

I've always found Understanding the perspective difficult. Is it really necessary to know it thoroughly?

basics will help you paint better pictures.

The thought of having to master the rules of perspective does deter a lot of people from attempting subjects that involve buildings. It is helpful to understand the basics, but observation shows you the main one - that objects appear to get smaller the further away they are. The commonest confusion, which is evident in the student's picture, is how to translate the correct angle of the tops of the walls, so as to produce a convincing sense of the buildings receding in the space. Your knowledge about an object can conflict with what you see. The student knows that to build a wall, the top and bottom have to be parallel, but he has not taken into account that a wall appears to get smaller towards the horizon, and parallel lines appear to converge.

the solution

Most problems with perspective arise from the inability to believe what you see. Careful observation is the solution to most drawing difficulties. Don't put in more than you can see, and if there is something you don't understand, investigate it - don't avoid it. For instance in Jann T. Bass's Desert Pipes we can see the thickness of the wall under the bell far more clearly than in the student's picture because the artist has understood and correctly observed the changes in angle at the top of the wall. Beginners often spoil an otherwise strongly composed painting by producing flat or contradictory perspective. Making your pastel marks follow the direction of a surface as it recedes from you can also be helpful. The student's unvarying vertical marks do not help to disentangle the walls from one another, and they do not convince us that each wall is 90 degrees to the next one. In the artist's painting much care has been taken to capture the surface differences between old brick and crumbling plaster.

Angles A very reliable technique when drawing and painting is to have a long straight-edge available - a long pencil, ruler or thin straight stick. Imagine that you have a plate of glass in front of you, representing the surface of your paper. When you want to find out the angle of a roofline or window top, hold out your straight-edge at arm's length, keeping it parallel to the flat surface of your imaginary glass, and angle it till it coincides with the line.

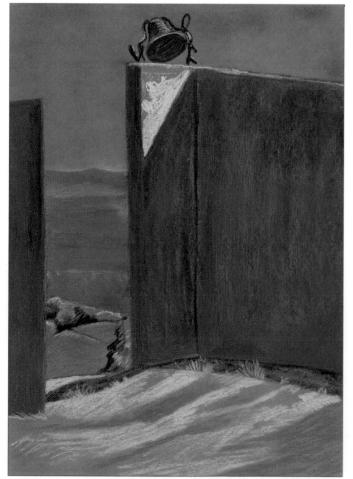

Student's version

Desert Pipes by Jann T. Bass

It is important that you have your easel and board conveniently placed so that all you have to do is turn, keeping your arm straight, and place your straight-edge on your paper giving you the correct angle.

Convincing details The student's picture was let down by poorly observed features. The windows, for example, have no depth; there is no sense of walls having thickness, with the windows set into them. In Openings (overleaf) the artist has given a convincing impression of the little narrow door set into the wall by observing the effects of

light and shade. The underside of the door lintel casts a shadow which defines both the thickness of the wall and the irregular shape of the lintel. We can also see the structure of the door, with its panel and inset window panes.

Buildings as design To make a painting involving buildings does not have to mean painstaking architectural study. A building can be used as an element of design, perhaps to contrast with natural forms or with depth and space in landscape.

The surface of a building is an important characteristic, which you should try to suggest, as the artist has here. The smooth but slightly irregular surface of the walls has been suggested with variations in a range of sand colours, helped by the lightly gritted surface of the paper.

Beach House LOIS GOLD

When a division in one wall, like the bottom edge of the verandah canopy, appears to run unbroken – even though we know that one wall is ninety degrees to the other the student will often not admit the evidence of his own eyes. When Lois Gold stood on the sand dune, her eye level was

at the same height as the bottom edge of the verandah, so the line appeared unbroken. Had she been higher, then the line would have risen from the left and right to meet at the corner. Had her eye level been lower, the line would have fallen from the left and right before meeting at the corner.

Town Scene PIP CARPENTER

Problems of perspective have been largely sidestepped in this pastel painting. There is the relative flattening of space that is characteristic of looking at something from a long way off. However, there is a strong sense of scale: the chimney pots in the foreground are as big as the houses on the skyline.

painting PEOPLE

I would really like
to improve my
figure drawing. Do
you have any
suggestions?

Student's version

A

Practise drawing figures from different angles, comparing the parts of the body against each other to keep everything in proportion.

the PROBLEM

Everyone thinks that they know what a person looks like, but unfortunately this is one of the main problems. We cannot rid ourselves of preconceptions, and instead of looking, we draw what we think we know. The student's sketch for a painting is wrong because she has not trusted her eyes. She knows that an arm is longer than a hand, but has not taken into account the fact that the arm is foreshortened, making the hand appear to be bigger than the rest of the arm. But knowledge of human proportions, although no substitute for observation, can save obvious mistakes. The student has forgotten, or perhaps not learned, that the face is only a small part of the head; here there is not enough head above the face.

the solution

It is not a bad idea when you draw anything to pretend you have never seen it before – this way you come to it fresh, with no preconceptions. The life drawing classes at which I teach are quite crowded, so when my students have settled and I want to draw, I may have to climb on a

table to see anything. This helps to build observational skills because it presents you with unusual views; it also gives a dramatic sense of scale. You can see this in the painting opposite, where the height of the man's head and shoulders at bottom left is as big as the whole of the model's figure in the centre. So again, careful observation is paramount.

Comparison and measurement Most artists use some system of measurement for figure drawing. The one I prefer is to directly compare one part with another. Taking the head as the basic unit, hold a straight-edge at arm's length to see how many head lengths fit into the body. Some artists work sight size, which means that when they hold out their straight-edge to measure, that exact measurement is transferred to the paper. The disadvantage of this method, especially in a life class where you may be some distance from the model, is that your figure is going to be quite small, so I find the comparison method more satisfactory. In the drawing above I would have compared the size of the head with the upper arms, to the depth of

Lighting This drawing was made using hard pastels and charcoal on a grey pastel paper. The shadows cast by the sofa and the highlights on the figure indicate that the light source is high and to the right. In fact, the lights were at the top of the shiny metal pole towards the right of the picture.

Louise, Pregnant by David Cuthbert

her pregnant bulge. Wherever possible I take absolutely vertical or horizontal measurements, as they can be found again easily. All figures exist in space. Another failing of the student's drawing is that there is no real sense of space between the spectator and the model. This can be solved by organizing the whole of your composition so that the model is not a separate entity floating on the paper but is part of the sofa, or part of the room. Where you can't quite see the edges, because they are lost against folds of cloth or disappear into shadow, let them disappear; the overall sense of space will benefit.

painting FLOWERS

My flowers look flat and heavy; I have lost the delicacy of the petals. What can I do?

Student's version

Mixing colours on your painting surface can produce a heavy feel and loss of delicacy. Use a variety of readymade tints in a limited range of colours instead.

the PROBLEM

You have to ask yourself what is it that excites you about a floral subject. For the student, in spite of the question, it seems to have been mainly the colour, but the colour has overwhelmed the forms and individual shapes, and the uniformly heavy marks give no feeling of the fragility of the flowers. You do not have to describe each bloom in detail, indeed a painting can fail because botanical correctness takes precedence over painterly considerations, but flowers should look recognizable. They have their own characteristic shapes and growth habits, and it is a pity to sacrifice what is most interesting about the subject.

the solution

There is an art to arranging flowers, but most flower painters prefer a less formal arrangement than that which you would find in a florist's display. If you tackle an indoor group, try to make it look natural, and don't cram it with too many different colours which will all fight for attention. Flowers thrown onto a newspaper make an attractive and unusual subject, or you can get very close to one flower as has Kitty Wallis for her *Rubrum Lily*. The great advantage of such a close view is that the shapes and colours of the petals can be closely observed and effects of light thoroughly investigated.

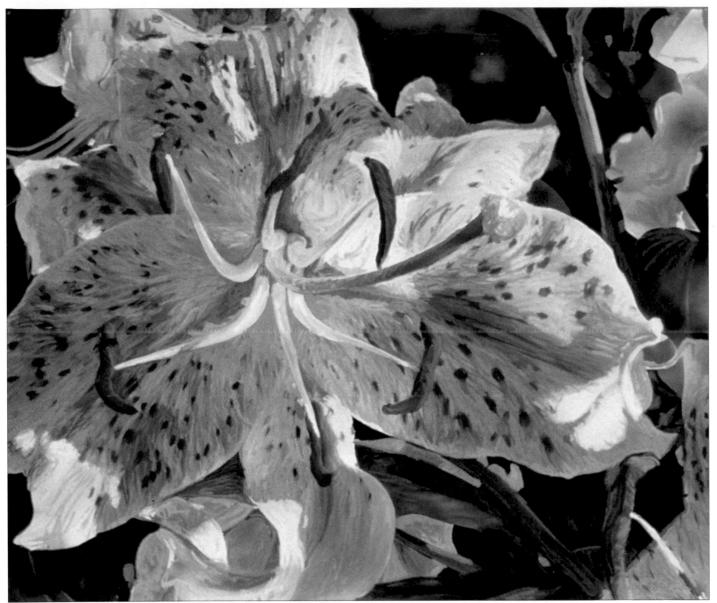

Rubrum Lily by Kitty Wallis

Pastel tints When painting something as subtle as a flower it is wise to have a good selection of colours, including several tints of each main colour. Some colours are sold in as many as eight tints, darker and lighter versions of a colour, which are made by adding white or black. The advantage of using the precise tint is that it cuts down on the amount of mixing you do on the paper. Overmixing tends to give a heavy, worked-over surface which will make your flowers less delicate than they could be.

Mark-making Petals, except when they are pressed in books, are never flat, they curl, they have veins and sometimes there are deep lines, as there are down the centre of each petal in Rubrum Lily. Try to use your pastels so that they follow these linear patterns, as Kitty Wallis has done to emphasize the way everything radiates from the centre of the flower. Fine lines stream down each shape and change tint as they cross shadows. The stamens are made with solid marks, but even these follow the form.

This is a very large painting, so that the marks you can see will be as broad as the end of a pastel stick. Working on a smaller scale, you would have to cut your pastel to an edge to get a sharp enough mark. Or you might use a pastel pencil, although you would not achieve such richness of colour.

Lily Entry ROSALIE NADEAU

The strong diagonal of the fence and the dark verticals are very important in bringing a geometry to set off against the frothiness of the flowers.

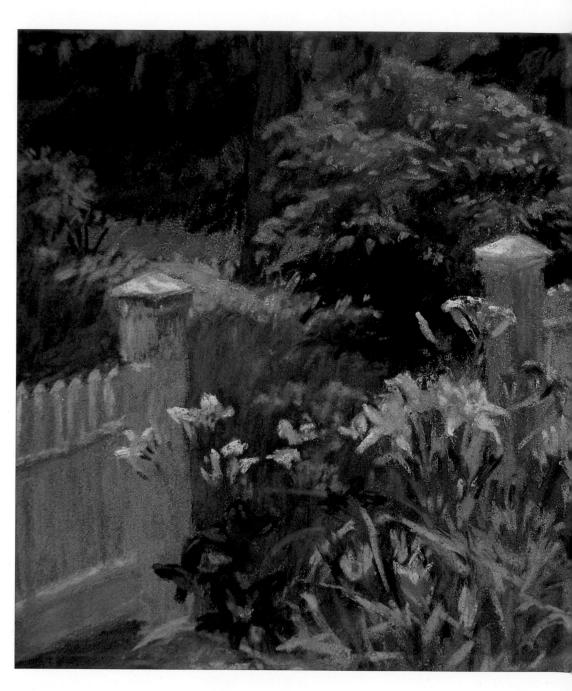

Line Flower painting does not have to be soft and gentle. A tough and strongly linear interpretation can be seen in Pip Carpenter's *Sunflowers*, a powerful drawing using hard and soft pastels, where even the colour is secondary to the vigorous lines of drawing. This approach would not suit all flowers but works particularly well with these overripe blooms.

Gardens You don't have to pick flowers and arrange them. Parks and gardens are ideal places to find colourful arrangements of flowers. Here you can forego too much detail provided you have a good composition and you catch the character of each flower type. Notice how few marks Rosalie Nadeau has used to describe each flower head in *Lily Entry*. This is an unusual composition, with

Sunflowers PIP CARPENTER

The glass tankard acts as a strong rectangular foil to the wriggling petals and leaves around the ellipses of the

sunflower heads. Strong blue and green lines describe the ragged waving of the petals against a varied background of diagonal hatching.

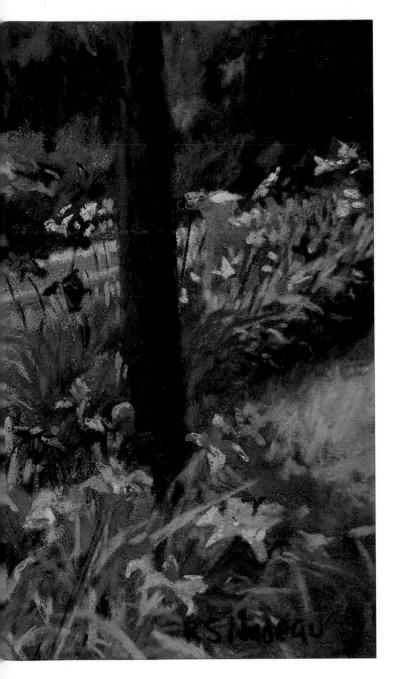

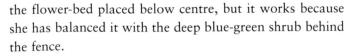

Diagrammatic analysis

Notice how the flower heads are both at a slight angle to the picture plane so that there is an interesting conjunction of ellipses.

surface shine & REFLECTIONS

The reflections

don't look realistic,

but I can't pinpoint

what's wrong.

the PROBLEM

There are two common reasons for failing at this subject. One is overdoing the reflections – putting in too much – and the other is losing sight of the shape of the object so that the reflections contradict the forms. The student has made both these mistakes, becoming so engrossed in the reflections that they seem to exist apart from the object. All form and local colour have been forgotten.

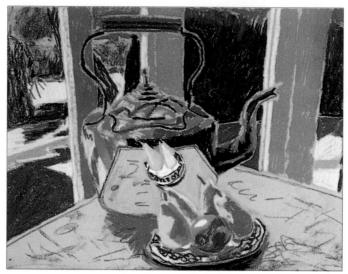

Student's version

The shape and colour of an object will always be stronger than the reflection, so don't let the reflection overpower it.

the solution

Rosalie Nadeau has had a slightly easier task, as the polished mahogany table is a flatter surface, so the reflections are less intricately shaped. But notice how she has given an impression of the table's actual colour. The reflected vase, patches of sky and window bars are modified by the colour of the table, and are softer on the table than they are on the vase and window frame itself; the reflections are less distinct than the objects that cast them. Notice also how the reflection describes the surface, changing in shape from the narrow part of the table to the slightly raised drop leaf. The leaf is more polished, so the contrasts are more marked than the muted colour in the narrow section. The artist has stood back from her subject frequently so that she could see each part in relation to the next, whereas the student's picture bears all the hallmarks

Pamet View by Rosalie Nadeau

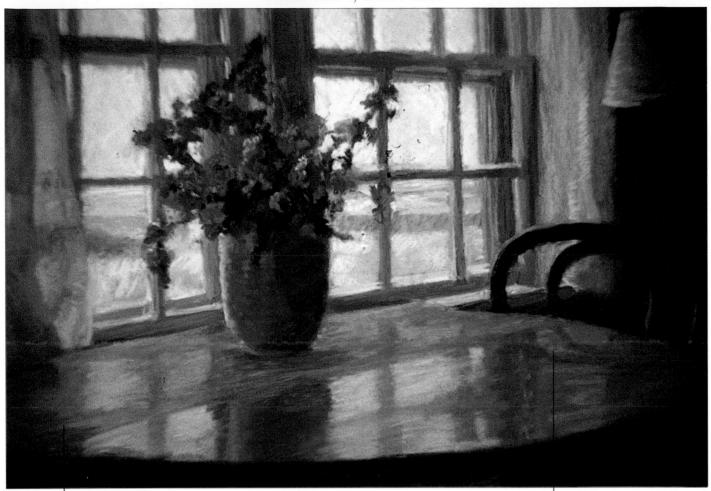

Creating subtle reflections There is some beautiful pastel work in this detail. We can just see the bars of the window through the curtain, the reflection of it in the table is very subtle indeed.

of someone working too close for too long, which results in failure to see the picture as a whole.

Select what you need All picturemaking involves making choices. Any subject will present you with an array of visual stimuli, but don't be tempted to over burden your picture with everything you can see; you can always do more than one picture of the same thing, emphasizing different aspects. In Rosalie Nadeau's painting, the reflection plays an important role in bringing light and colour into the foreground, but it is not the focus of interest; the flower vase is.

Light Sometimes it helps to forget what an object is, to forget its name and just concentrate on what you can see, rather than think about what you know. If you trust your eyes, you are responding to light. Light illuminates objects but sometimes seems to destroy them when they pick up strong reflections. If you are constantly asking yourself what something is, you are likely to put in too much detail just to illustrate what you know is there. Always paint what you see!

Colours of reflections

The reflection of the chair is very subtle, the back nearest the window is not visible in the narrow section of the table, which must be less reflective, than on the drop leaf, where we can see a blue-mauve image. The extreme edge of the window casement, which is yellow ochre, becomes almost a raspberry colour on the mahogany table.

INDEX

98, 99

Trees and Bird 80, 80, 81

Page numbers in italics refer to Chardin, Jean-Simeon 98 Cuthbert, David: flowers 136-9, 136, 137, 138-9 illustrations and captions Chinese ink, colouring paper The Artist's Father 56 focal point 88 with 21, 21 Carole 84, 85 focus 72-3 Christensen, Deborah, Corner of the Studio 72, 73 foliage 110-11, 110, 113 Mountain Serenity 122-3, foreground 90-1 Evening Light, Fiesole 48, 49 Louise, Pregnant 134, 135 formats 67, 67, 71 clouds 118-19, 118, 119, 120-1 Olive Grove 82 framing 29 shadows of 117 abstracting from nature 80-1, Cuthbert, Rosalind: 80, 81, 82-3 clutcher eraser 16, 17 Above Lake Tenno 68, 69 colour wheels 31 acrylic: Pots from Chateau des Fours colours 30 as fixative 21 affected by surrounding mixing with pastels 12, 12, Tom at Home 106 colours 59-60, 59 Gallwey, Kay, Still Life with complementary 37, 59-60, for texturing 22 Fruit and Paintbrushes 100 underpainting with 20 62 Gold, Lois: aerial (atmospheric) perspective contrasts 44-6, 59-60 A Feeling of Spring 118-19, 52, 94 cool 31, 46, 47 119 aerosol fixative 16, 16 darkening 46, 47 Dawson, Doug: Beach House 132 effect of fixing 26 Aggett, Lionel, St Agnes Road, Alberta 54-5, 55 gouache: Cornwall 121 equivalents 60 Canal Bridge 25 adding texture with 23 greens, for landscape 50-3, asymmetry 76, 77, 79, 84 Street of the Golden Dragon mixing with pastels 12 97, 97 underpainting with 20, 21 for highlights 64-5, 64, 65 Day, B Sanford, Kills Enemy gummed paper strip 16, 17 identifying 36-7 Cool 56 light, delicacy of effect 38 Degas, Edgar 96-7 lightening 46, 47 Deichler, Deborah: mixing 30-1, 32-3, 33 background, of still life 99, Aerial Plum 103, 103 Н muddy, avoiding 40 102-3, 102 Nikki 34 primaries 31 Balasz, Suzie, St Mark's Square, Sarah P 106 hard pastels 10-11, 10 secondaries 31 Sideboard 65, 65 Venice 108 mixing with other types 12 Bass, Jann T: of shadows 62 Still Life 61 hatching 41, 86 for skies 118-19 Mesa Quiet 8 Delacroix, Eugène 96-7 highlights 64-5, 64, 65, 103, skin tones 54-5 Openings 131, 132 depth 91, 114 121 temperature 31, 46, 47 Otono 37 detail: horizon 119, 119, 120 Bonnard, Pierre 81 tertiaries 31 editing out 74-5, 74, 75 tints 137 Bray, Rima, View from keeping to minimum 9 tones 44-6, 127 Greenwich Park 75, 75 diffuser 16, 16 unity 48, 49 broken colour 85 tinting paper with 21, 21 warm 31, 46, 47 direction lines 84 buildings 130-1, 130, 131, composition 66-107 132 - 3drawing board 16, 17 impasto 23 Burshell, Sandra: controlling subject 88, 89 dust sheet 16, 16 Impressionists 62, 74-5 dynamism 84, 85, 86 Despair 79 dynamism 84, 85, 86 placing subject 76, 77 The Study 76, 77 Constable, John 62, 118 Tranquil Corner 47 conté 12, 15, 73 Warm Light 101 contrasts 115, 115 Butcher, Irene Christiana, E contre jour 50 Country Road 38, 39 Jordan, Maureen, Peace Roses cotton buds 16, 17 easel, working at 26 cotton wool 16, 17 Edgerton, Charmian, Breakfast craft knife 16, 16 on Wedgwood 42 Crittenden, James: edges 72-3 Forest Scene 50, 51 to suggest movement 86 K Orange Grove in the camera obscura 96 equipment 16, 16-17 Evening 52-3, 53 canvas, pastel on 23 erasers 16, 17 Katchen, Carole, In the Spain 71 care of paintings 28-9 Shadows 42 cropping 70 Carpenter, Pip: Kent, Jean: crosshatching 86 Sunflowers 138, 139 Still Life with Pomegranates

figures see people

fixing 28-9, 28-9

fixatives 16, 16

Cullen, Patrick:

Bright Morning 95

Rooftops 130, 131

Red Cabbages 59, 59, 60

Thames Docklands 94

Town Scene 133

charcoal 12, 40, 41, 73

charcoal pencil 16, 17

chalk pastels 10, 11

storage 29, 29 portraits: stroke work 91 composing 104-5, 104, 105, landscapes: oil pastels 10, 11, 12 106 - 7Strother, Jane: Gechena 112 composing 68 correcting 109 formats 67 Scottish Tourist 78 foreground 90-1 lighting 107 fixing 28 formats 67, 70 mixing 13, 35, 35 posing model for 107 stump 16, 17, 32 Prentice, David, British Camp supports 22-4 greens for 50-3 mixing with other media 12 palette 53 supports for 23, 35 Reservoir, Malvern 52, 52 using 23 surfaces 72 paper colour for 19 Oliver, Alan, Beach Scene 120 problem areas 108-41 shine and reflections 140-1 protective mask 16, 17 viewpoint 70, 90-1 lighting 56 pumice powder, for textured 140, 141 for people 135 surface 22, 23 for portraits 107 putty rubber 16, 17 for still life 64-5, 103 line work, pastels for 10 paint, mixing pastels with 12 palette 30 basic 14-15, 14, 15 tints 15 trees 110-11, 110, 111, 112-13 extending 58-60 reflections: in winter 114-15, 114, 115 paper: hook of 16, 17 on shiny surface 140-1, 140, Turner, J M W 119 colouring 20-1, 21 McLeane, Jody Depew: through stencils 21 on water 122, 123, 124, 125 Brenda's Café 107 colours 18-21, 18, 20 Renaissance 55, 92 The Juggler 87 The Paper 61 showing through pastel U Practice 66 18-19, 18 size 26-7 Manifold, Debra, Lakeside, underdrawing 11, 12 for skies 121 underpainting, for skin tones, Autumn 112 mark-making 84, 85, 92, 93, stretching 22, 24 55, 55 sandpaper 22 textures 21, 22-5, 22, 23 93, 113, 127, 137 scale 75, 87, 133 applying 22, 23, 24 Marylies, Simie: shadows 41, 42, 43, 62, types 22 Foggy Morning on the Pamet watercolour 21 116-17, 116, 117 124 "sight size" 27 Sunset after Rain 43 white 18 Meyer, Milton, View of San pastel board 22 Simmonds, Jackie: viewfinder, using 70 Crystal Waters 126-7, 127 Giorgio Maggiore, Venice pastels: viewpoint, choosing 70 Ubud Market Scene, Bali 88, blending 14 120 mistakes, correcting 109, 109 grind fragments 21 layering 32-3, 33, 34 sketchbook 8, 9, 108 model, posing 107 mixing, methods 32-3, 33 sketches 80-1, 80 Monet, Claude 96-7 W skies 118-19, 118, 119, 120-1 mixing with other media 12 movement 86, 87 mixing types 10, 12, 13 of water 126-7, 126, 127 skin: Wallis, Kitty: tones for 54-5 types 10 Mutimer, Ray, Evening 114-15, Portrait 105, 105 pencil pastels 10, 11, 11, 26 underpainting 55, 55 Rubrum Lily 136, 137, 137 Mynell, David, Richmond 19 mixing with other types 12 Smith, Elizabeth Apgar, First people 134-5, 134, 135 Ride 86, 87 moving 126-7, 126, 127 snow scenes 128-9, 128, 129 see also portraits reflections on 122, 123, 124, soft pastels 10, 10, 11 measurement 134-5 125 perspective 88, 89, 91, 92, 119, correcting 109 shadows on 117, 117 N 120, 122, 130, 133 mixing with other types 12 still 122, 122, 123, 124-5 atmospheric (aerial) 52, 94 over acrylic 12 Nadeau, Rosalie: watercolour: space, creating 88, 92-3, 92, Bather 63 photographs, working from mixing with pastels 12 93-5 96-7, 96, 126 Cottage by the Coast 46 underpainting with 20 spatter 21 Pitts, Mary Ellen, Ribbons of Fall Fire 60 watercolour paper see paper Sunshine 116-17, 117 sponge 16, 17 Lily Entry 138-9, 138 Wood, Robert Maxwell: Stanton, Jane, River and Rocks Pamet View 140, 141, 141 Polk, Kay, Bloomin' Paradise 30 Backyard Snow 128-9, 129 43 Popkin, Elsie Dinsmore: Ruggles Farm House 33, 33 Reclining Nude 57 Ebbtide with Resting Gulls stencils 21 Snow Shore 94 Trees 110-11, 111 92-3, 93 still life: Winter White 90-1, 91 backgrounds 99, 102-3, 102 nature, abstracting from 80-1, Lake Katrina - September

Triptych 124

45

Nude with Striped Skirt 45,

80, 82-3

nudes, paper colour for 19

composing 98, 98, 99-101

surfaces and edges 72-3

lighting 64-5, 103

CREDITS

Quarto would like to thank all the artists who kindly allowed us to publish their work in this book.

We would like to acknowledge the following owners of featured work:

Barry and Lexie Cohen, page 138; Cummaquid Fine Arts, Cape Cod, Massachusetts, pages 60 and 90; Ellen Haynes, page 46; Meredith Mark, page 94; Georgie Paul, page 33.

The work of Simie Maryles appears courtesy of the Lizardi/Harp Gallery, Pasadena, California.